RETRO DESIGNS

Coloring Book

Hand Drawn and Digital Images for Your Coloring Hobby

By: Kaye Dennan

KD Coloring Studio

http://kdcoloring.com

ISBN-13: 978-1545130339

Disclaimer

All Rights Reserved. No part of this publication may be reproduced in any form or by any means, including scanning, photocopying, or otherwise without prior written permission of the copyright holder.

Copyright © 2017 Kaye Dennan

Paperback Edition

Manufactured in the United States of America

Sample Images from this Book

Some images have lighter colored lines so that you can use lighter shades to color without the darker lines showing through. It is not a printing error that some pictures have two shades of lines.

A blank page has been left between each image so that following images are not ruined with impressions and color leakage.

I suggest an extra blank page or thin cardboard underneath the image you are working on.

80's MUSIC

RETRO

DANCE HALL

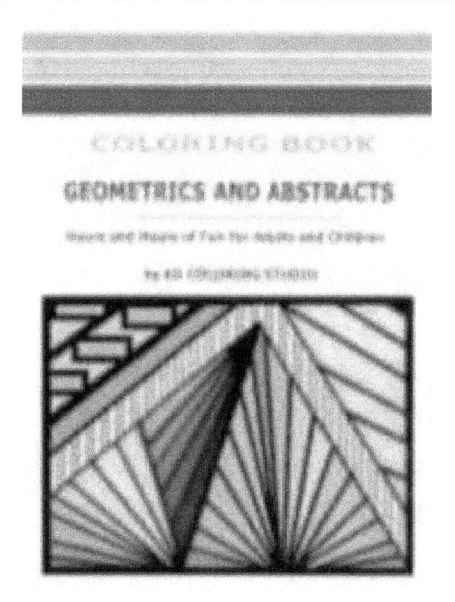

More paperback coloring books can be sourced through

KD COLORING STUDIO AT
http://kdcoloring.com

www.ingramcontent.com/pod-product-compliance
Lightning Source LLC
Chambersburg PA
CBHW060011210526
45170CB00017B/2306

Topic

Ref.

Date	Key Area

Key Points

Key Points	Notes
1	
2	
3	
4	
5	
6	
7	

Topic

Ref.

Date Key Area

Key Points

Key Points	Notes

Topic

Ref.

Date Key Area

Key Points

Key Points	Notes

Topic

Ref.

Date Key Area

Key Points

Key Points	Notes

Topic

Ref.

Date Key Area

Key Points

Key Points	Notes

Topic

Ref.

Date Key Area

Key Points

Key Points	Notes

Topic

Ref.

Date Key Area

Key Points

Key Points	Notes

Topic

Ref.

Date Key Area

Key Points

Key Points	Notes

Topic

Ref.

Date Key Area

Key Points

Key Points	Notes

Topic

Ref.

Date Key Area

Key Points

Key Points	Notes

Topic

Ref.

Date Key Area

Key Points

Key Points	Notes

Topic
Ref.
Date Key Area

Key Points

Key Points	Notes

Topic

Ref.

Date Key Area

Key Points

Key Points	Notes

Topic

Ref.

Date Key Area

Key Points

Key Points	Notes

Topic

Ref.

Date Key Area

Key Points

Key Points	Notes

Topic

Ref.

Date Key Area

Key Points

Key Points	Notes

Topic

Ref.

Date Key Area

Key Points

Key Points	Notes

Topic

Ref.

Date Key Area

Key Points

Key Points	Notes

Topic

Ref.

Date　　　　　Key Area

Key Points

Key Points	Notes

Topic

Ref.

Date Key Area

Key Points

Key Points	Notes

Topic

Ref.

Date Key Area

Key Points

Key Points	Notes

Topic

Ref.

Date Key Area

Key Points

Key Points	Notes

Topic

Ref.

Date Key Area

Key Points

Key Points	Notes

Topic

Ref.

Date Key Area

Key Points

Key Points	Notes

Topic

Ref.

Date Key Area

Key Points

Key Points	Notes

Topic

Ref.

Date Key Area

Key Points

Key Points	Notes

Topic

Ref.

Date Key Area

Key Points

Key Points	Notes

Topic

Ref.

Date Key Area

Key Points

Key Points	Notes

Topic

Ref.

Date Key Area

Key Points

Key Points	Notes

Topic
Ref.
Date Key Area

Key Points

Key Points	Notes

Topic

Ref.

Date Key Area

Key Points

Key Points	Notes

Topic

Ref.

Date Key Area

Key Points

Key Points	Notes

Topic

Ref.

Date Key Area

Key Points

Key Points	Notes

Topic
Ref.
Date Key Area

Key Points

Key Points	Notes

Topic

Ref.

Date Key Area

Key Points

Key Points	Notes

Topic

Ref.

Date Key Area

Key Points

Key Points	Notes

Topic

Ref.

Date Key Area

Key Points

Key Points	Notes

Topic

Ref.

Date Key Area

Key Points

Key Points	Notes

Topic

Ref.

Date Key Area

Key Points

Key Points	Notes

Topic

Ref.

Date Key Area

Key
Points

Key Points	Notes

Topic

Ref.

Date Key Area

Key Points

Key Points	Notes

Activities Checklist

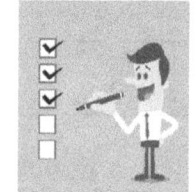

Date Key Area

Date	No.	Activity	Accountable	✓	Start	End

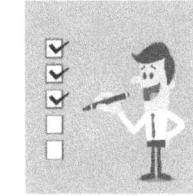

Activities Checklist

Date _____ Key Area _____

Date	No.	Activity	Accountable	✓	Start	End

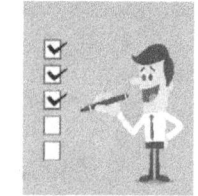

Activities Checklist

Date _____ Key Area _____

Date	No.	Activity	Accountable	✓	Start	End

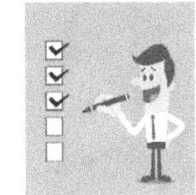

Activities Checklist

Date _____ Key Area _____

Date	No.	Activity	Accountable	✓	Start	End

Activities Checklist

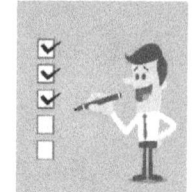

Date _____ Key Area _____

Date	No.	Activity	Accountable	✓	Start	End

Activities Checklist

Date _____ Key Area _____

Date	No.	Activity	Accountable	✓	Start	End

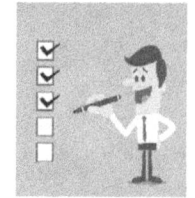

Activities Checklist

Date _____ Key Area _____

Date	No.	Activity	Accountable	✓	Start	End

Activities Checklist

Date _____ Key Area _____

Date	No.	Activity	Accountable	✓	Start	End

Activities Checklist

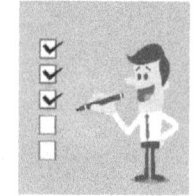

Date _____ Key Area _____

Date	No.	Activity	Accountable	✓	Start	End

Activities Checklist

Date _____ Key Area _____

Date	No.	Activity	Accountable	✓	Start	End

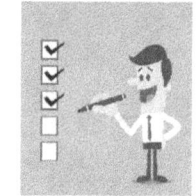

Activities Checklist

Date Key Area

Date	No.	Activity	Accountable	✓	Start	End

Activities Checklist

Date _____ Key Area _____

Date	No.	Activity	Accountable	✓	Start	End

Activities Checklist

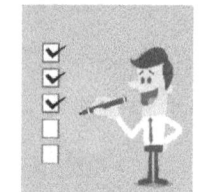

Date _____ Key Area _____

Date	No.	Activity	Accountable	✓	Start	End

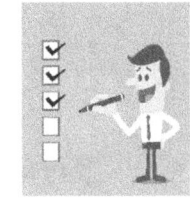

Activities Checklist

Date Key Area

Date	No.	Activity	Accountable	✓	Start	End

Activities Checklist

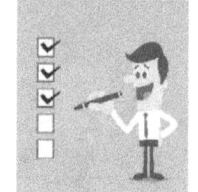

Date： _____ Key Area： _____

Date	No.	Activity	Accountable	✓	Start	End

Activities Checklist

Date Key Area

Date	No.	Activity	Accountable	✓	Start	End

Activities Checklist

Date　　　　　　　Key Area

Date	No.	Activity	Accountable	✓	Start	End

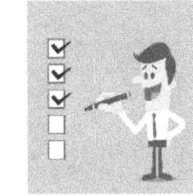

Activities Checklist

Date _____ Key Area _____

Date	No.	Activity	Accountable	✓	Start	End

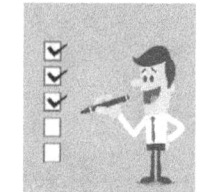

Activities Checklist

Date _____ Key Area _____

Date	No.	Activity	Accountable	✓	Start	End

Activities Checklist

Date | Key Area

Date	No.	Activity	Accountable	✓	Start	End

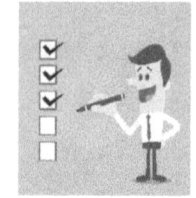

Activities Checklist

Date Key Area

Date	No.	Activity	Accountable	✓	Start	End

Activities Checklist

Date Key Area

Date	No.	Activity	Accountable	✓	Start	End

Activities Checklist

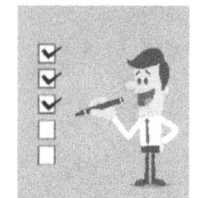

Date Key Area

Date	No.	Activity	Accountable	✓	Start	End

Activities Checklist

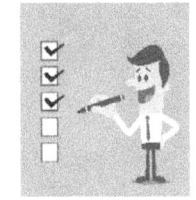

Date _____ Key Area _____

Date	No.	Activity	Accountable	✓	Start	End

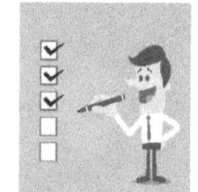

Activities Checklist

Date _____ Key Area _____

Date	No.	Activity	Accountable	✓	Start	End

Activities Checklist

Date Key Area

Date	No.	Activity	Accountable	✓	Start	End

Activities Checklist

Date　　　　　　Key Area

Date	No.	Activity	Accountable	✓	Start	End

Activities Checklist

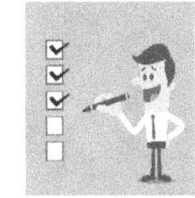

Date _____ Key Area _____

Date	No.	Activity	Accountable	✓	Start	End

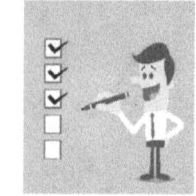

Activities Checklist

Date _____ Key Area _____

Date	No.	Activity	Accountable	✓	Start	End

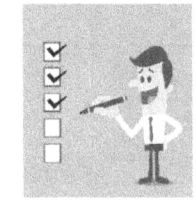

Activities Checklist

Date _____ Key Area _____

Date	No.	Activity	Accountable	✓	Start	End

Activities Checklist

Date _____ Key Area _____

Date	No.	Activity	Accountable	✓	Start	End

Activities Checklist

Date _____ Key Area _____

Date	No.	Activity	Accountable	✓	Start	End

Activities Checklist

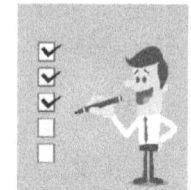

Date _____ Key Area _____

Date	No.	Activity	Accountable	✓	Start	End

Activities Checklist

Date　　　　　　Key Area

Date	No.	Activity	Accountable	✓	Start	End

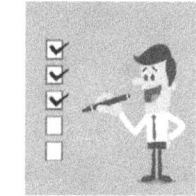

Activities Checklist

Date Key Area

Date	No.	Activity	Accountable	✓	Start	End

Activities Checklist

Date _____ Key Area _____

Date	No.	Activity	Accountable	✓	Start	End

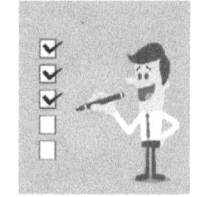

Activities Checklist

Date: _____ Key Area: _____

Date	No.	Activity	Accountable	✓	Start	End

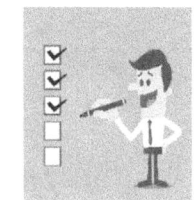

Activities Checklist

Date _____ Key Area _____

Date	No.	Activity	Accountable	✓	Start	End

Activities Checklist

Date Key Area

Date	No.	Activity	Accountable	✓	Start	End

Activities Checklist

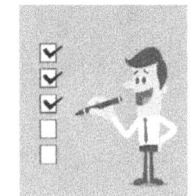

Date _____ Key Area _____

Date	No.	Activity	Accountable	✓	Start	End

Activities Checklist

Key Area

Topic

Activities Checklist

Key Area

Topic

Activities Checklist

Key Area _____

Topic _____

Activities Checklist

Key Area _____

Topic _____

Activities Checklist

Key Area

Topic

Activities Checklist

Key Area _____

Topic _____

Activities Checklist

Key Area

Topic

Activities Checklist

Key Area

Topic

Activities Checklist

Key Area

Topic

Activities Checklist

Key Area _____

Topic _____

Activities Checklist

Key Area

Topic

Activities Checklist

Key Area _____

Topic _____

Activities Checklist

Key Area _____

Topic _____

Activities Checklist

Key Area

Topic

Activities Checklist

Key Area

Topic

Activities Checklist

Key Area _____

Topic _____

Activities Checklist

Key Area

Topic

Activities Checklist

Key Area _____

Topic _____

Activities Checklist

Key Area _____

Topic _____

Activities Checklist

Key Area _____

Topic _____

Activities Checklist

Key Area

Topic

Activities Checklist

Key Area _____

Topic _____

Activities Checklist

Key Area

Topic

Activities Checklist

Key Area _____

Topic _____

Activities Checklist

Key Area _____

Topic _____

Activities Checklist

Key Area _____

Topic _____

Activities Checklist

Key Area _____

Topic _____

Activities Checklist

Key Area _____

Topic _____

Activities Checklist

Key Area

Topic

Activities Checklist

Key Area

Topic

Activities Checklist

Key Area

Topic

Activities Checklist

Key Area _____

Topic _____

Activities Checklist

Key Area

Topic

Activities Checklist

Key Area _____

Topic _____

Activities Checklist

Key Area _____

Topic _____

Activities Checklist

Key Area _____

Topic _____

Activities Checklist

Key Area _____

Topic _____

Activities Checklist

Key Area _____

Topic _____

Activities Checklist

Key Area _____

Topic _____

Activities Checklist

Key Area

Topic

Topic

Person in charge

Date

Record/Report

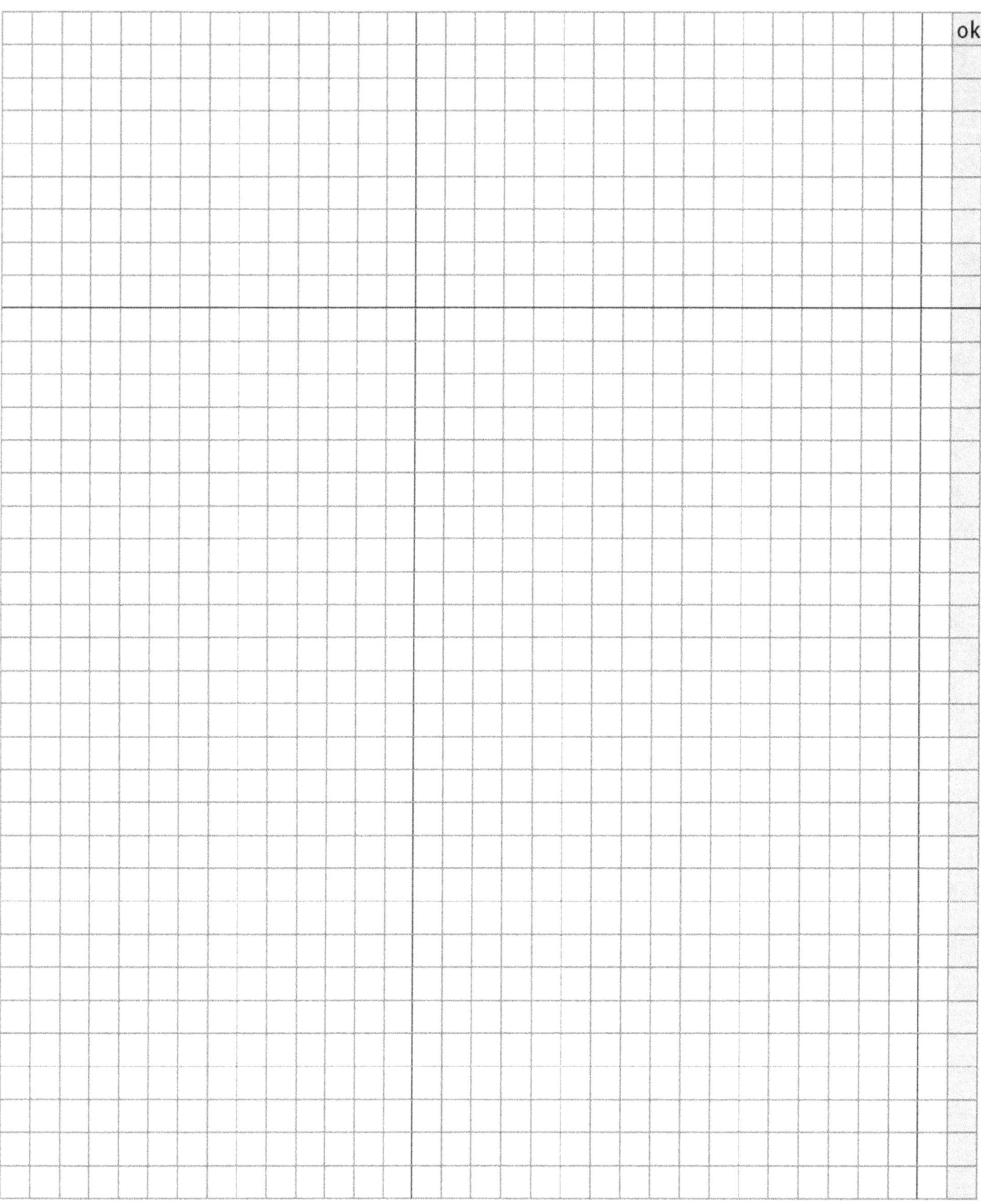

Topic

Person in charge

Date

Record/Report

Topic

Person in charge

Date

Record/Report

Topic

Person in charge

Date

Record/Report

ok

Topic

Person in charge

Date

Record/Report

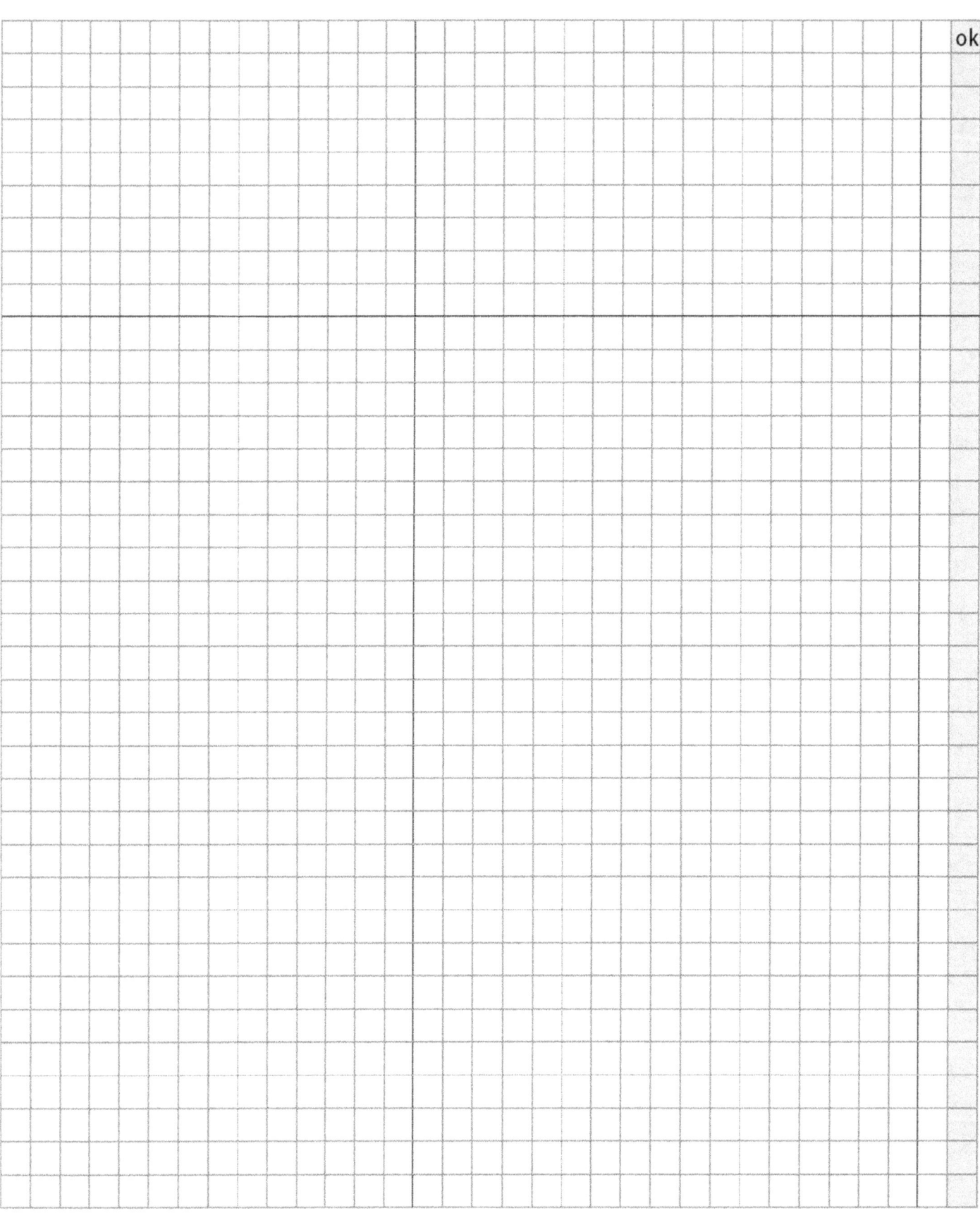

Topic

Person in charge

Date

Record/Report

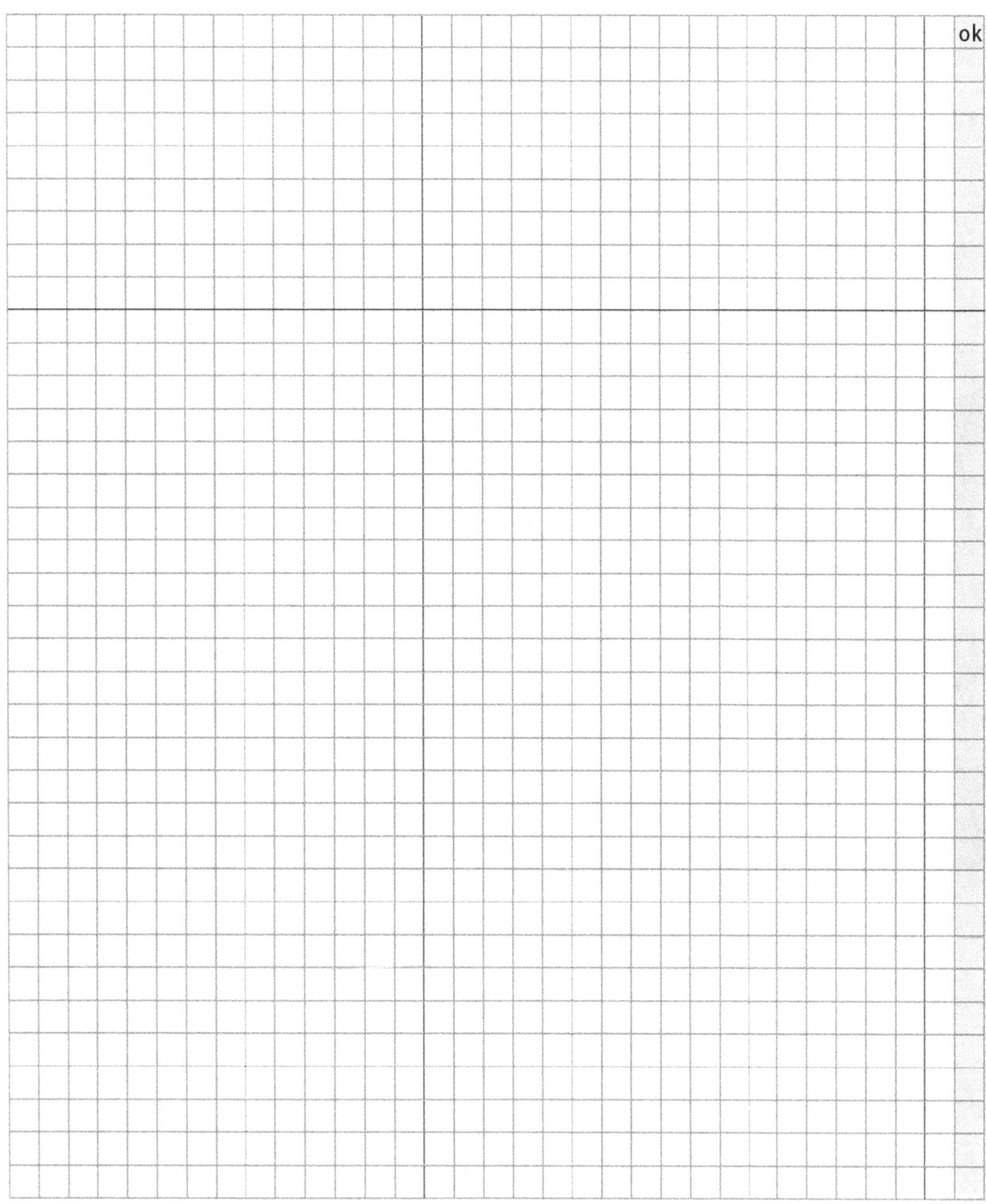

Topic

Person in charge

Date

Record/Report

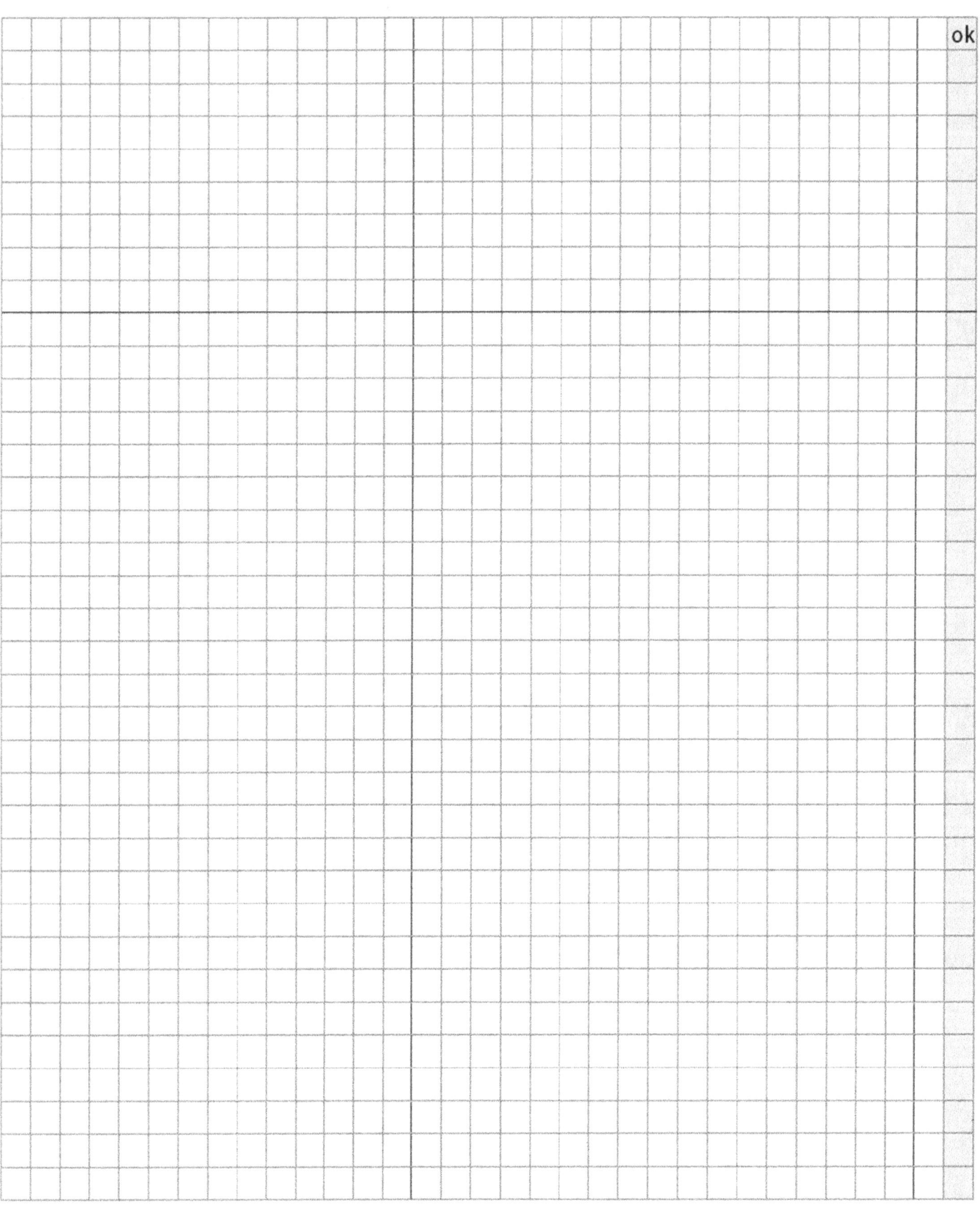

Topic

Person in charge

Date

Record/Report

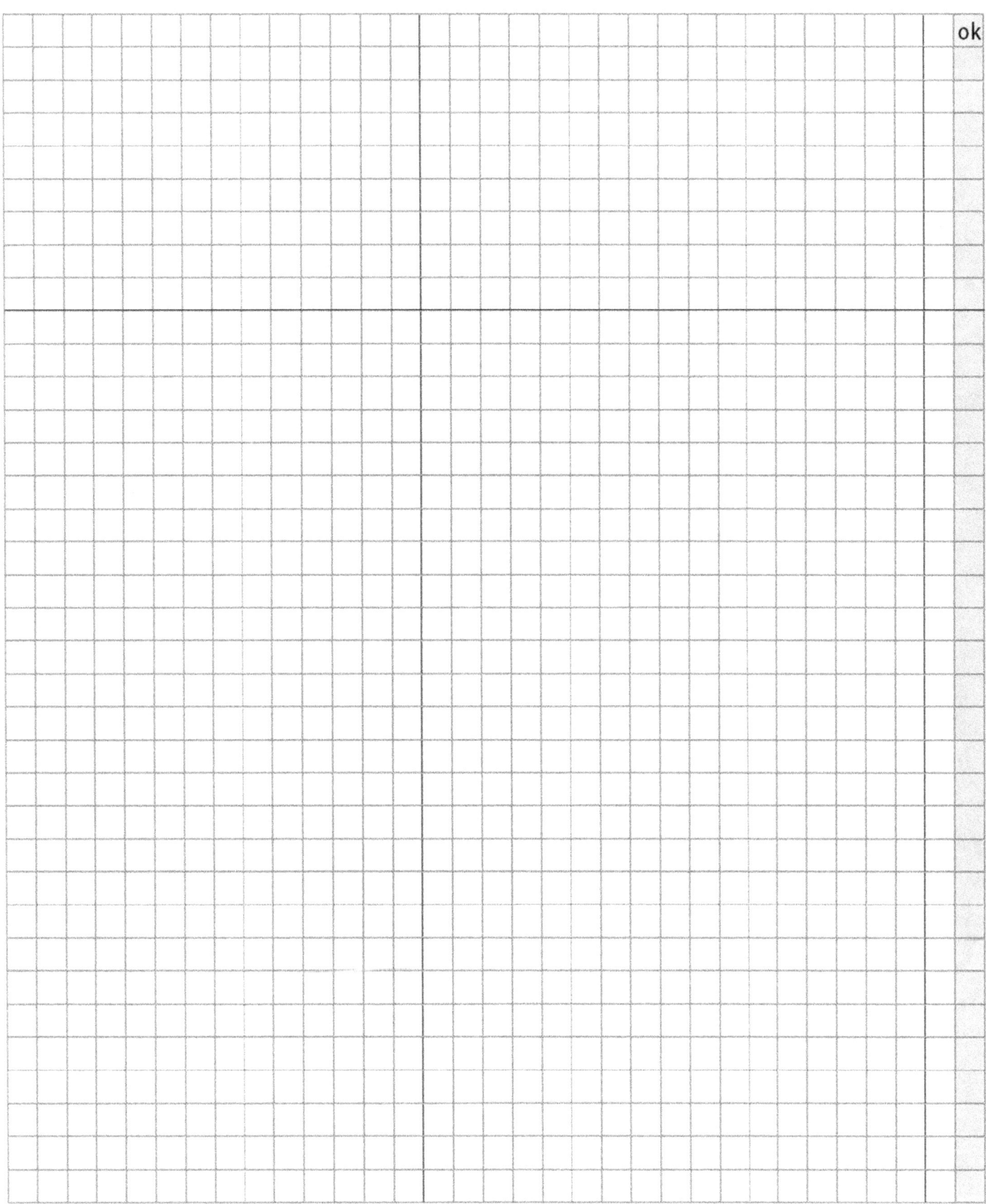

Topic

Person in charge

Date

Record/Report

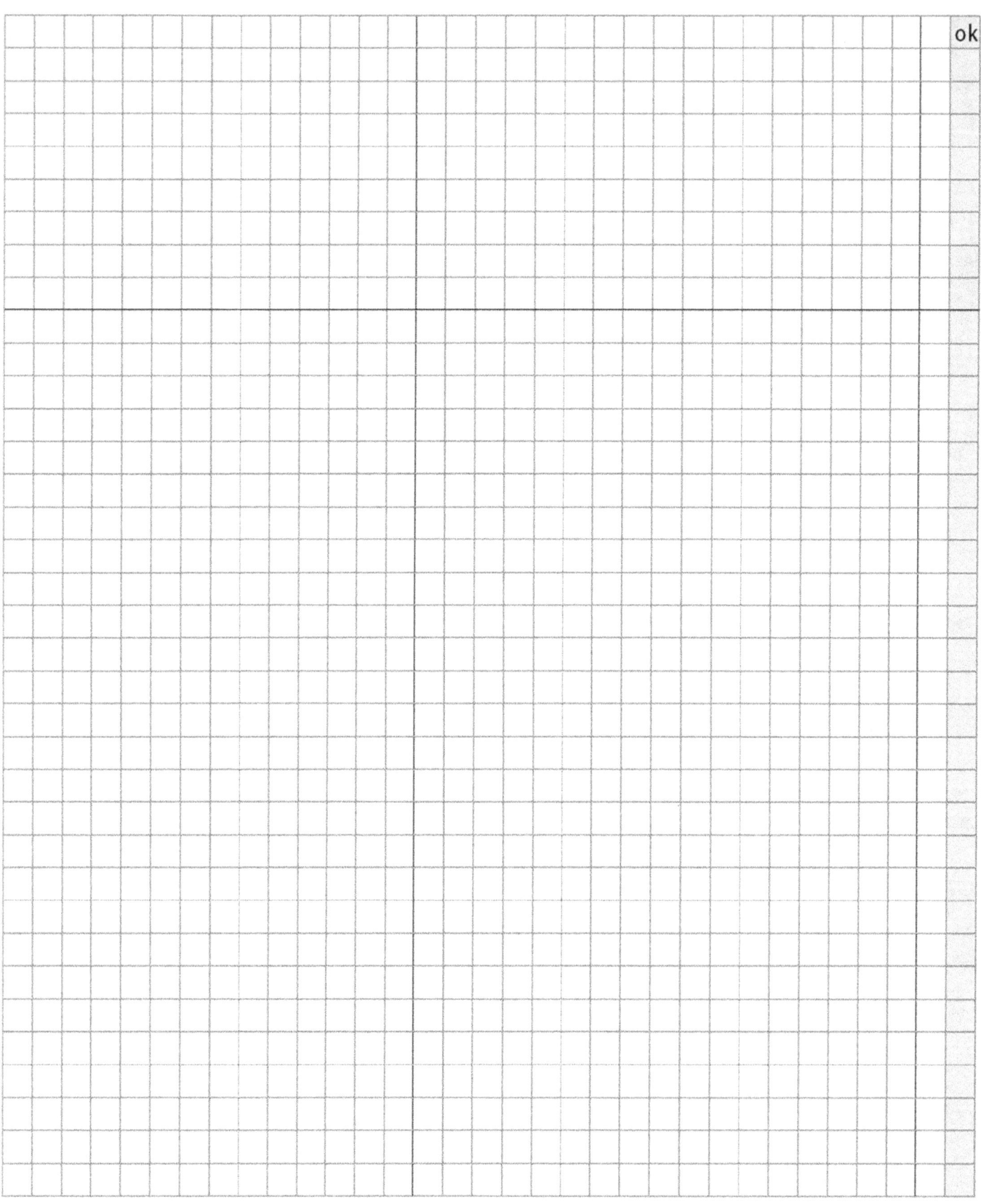

Topic _____

Person in charge _____

Date _____

Record/Report

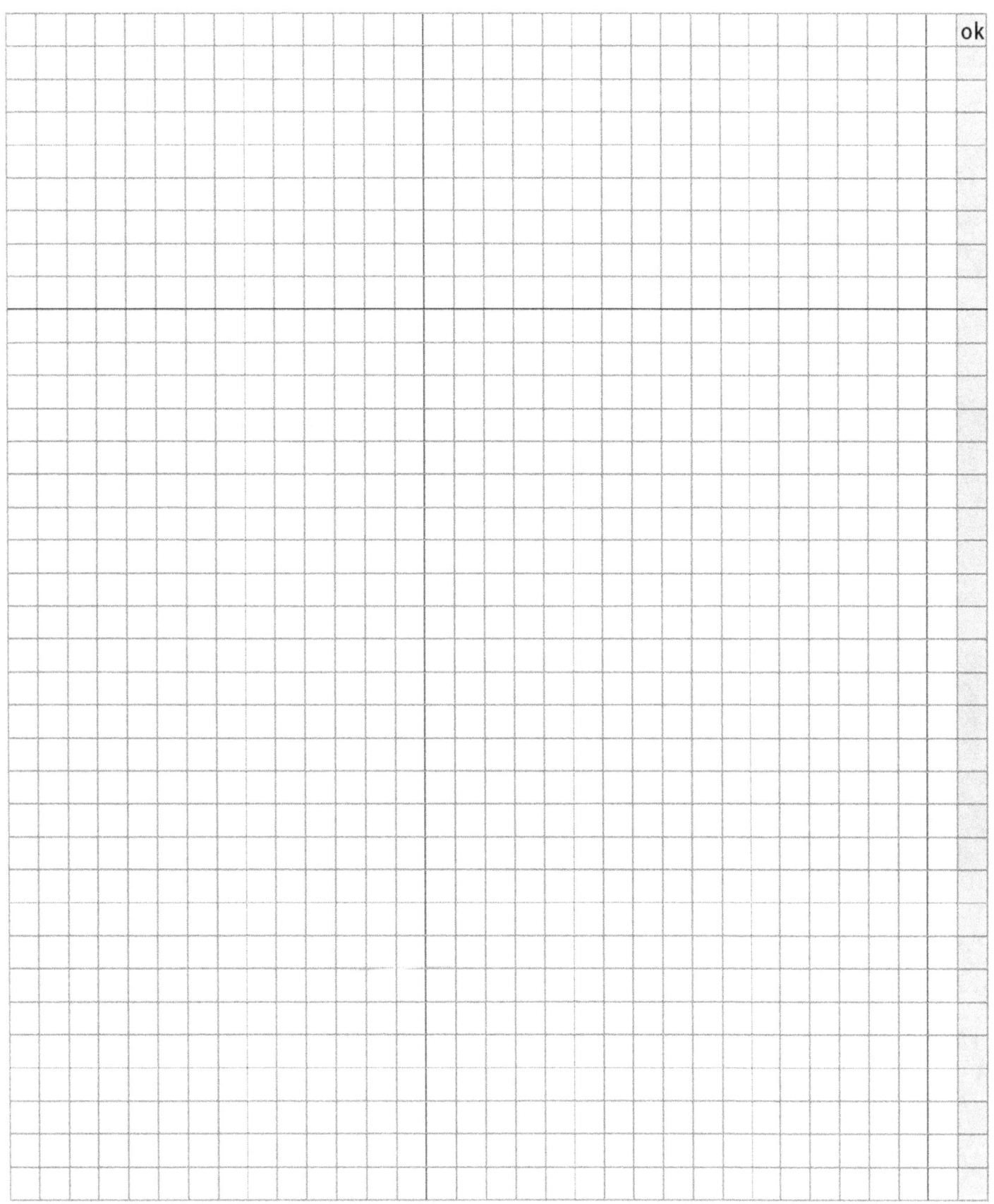

Topic

Person in charge

Date

Record/Report

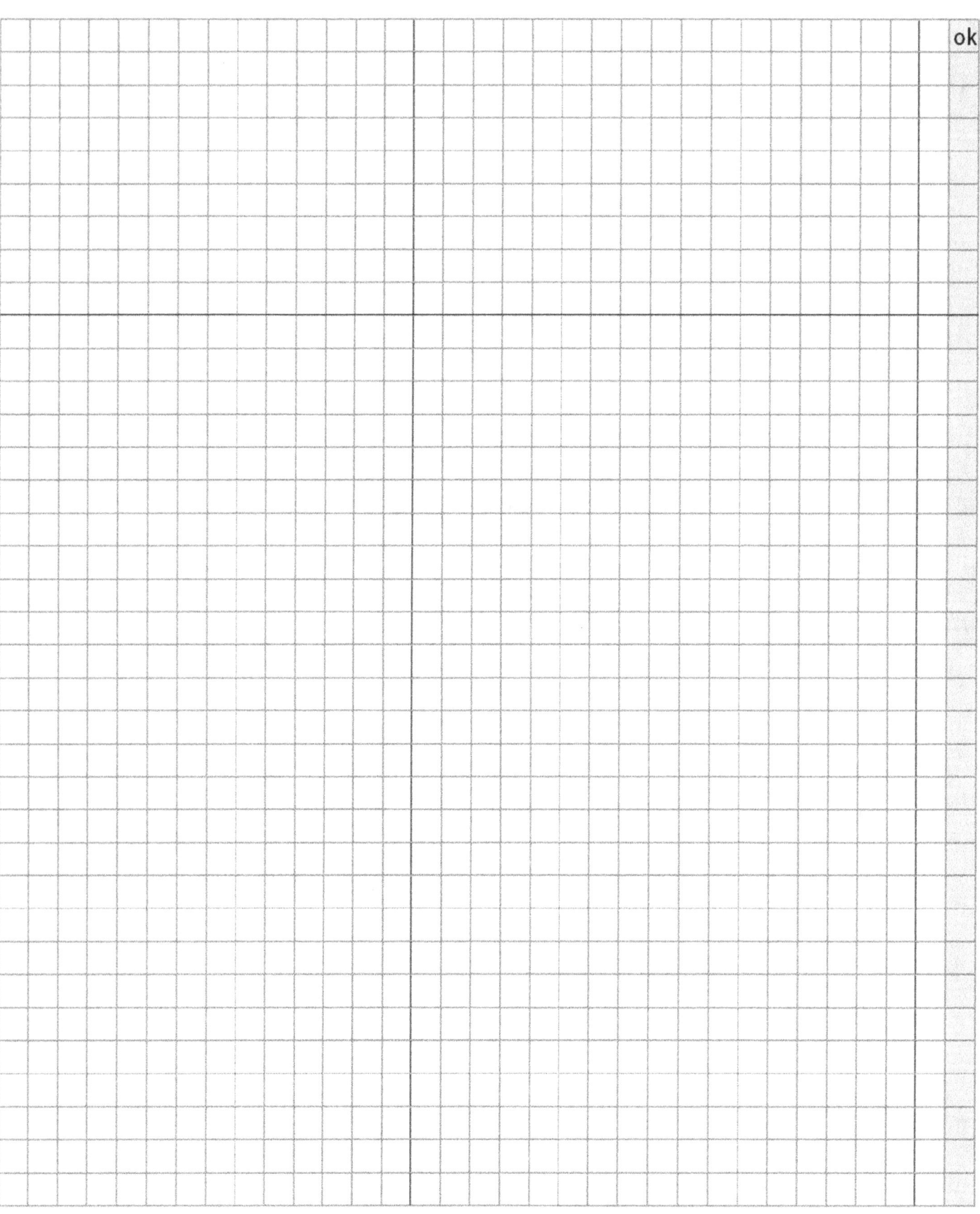

Topic

Person in charge

Date

Record/Report

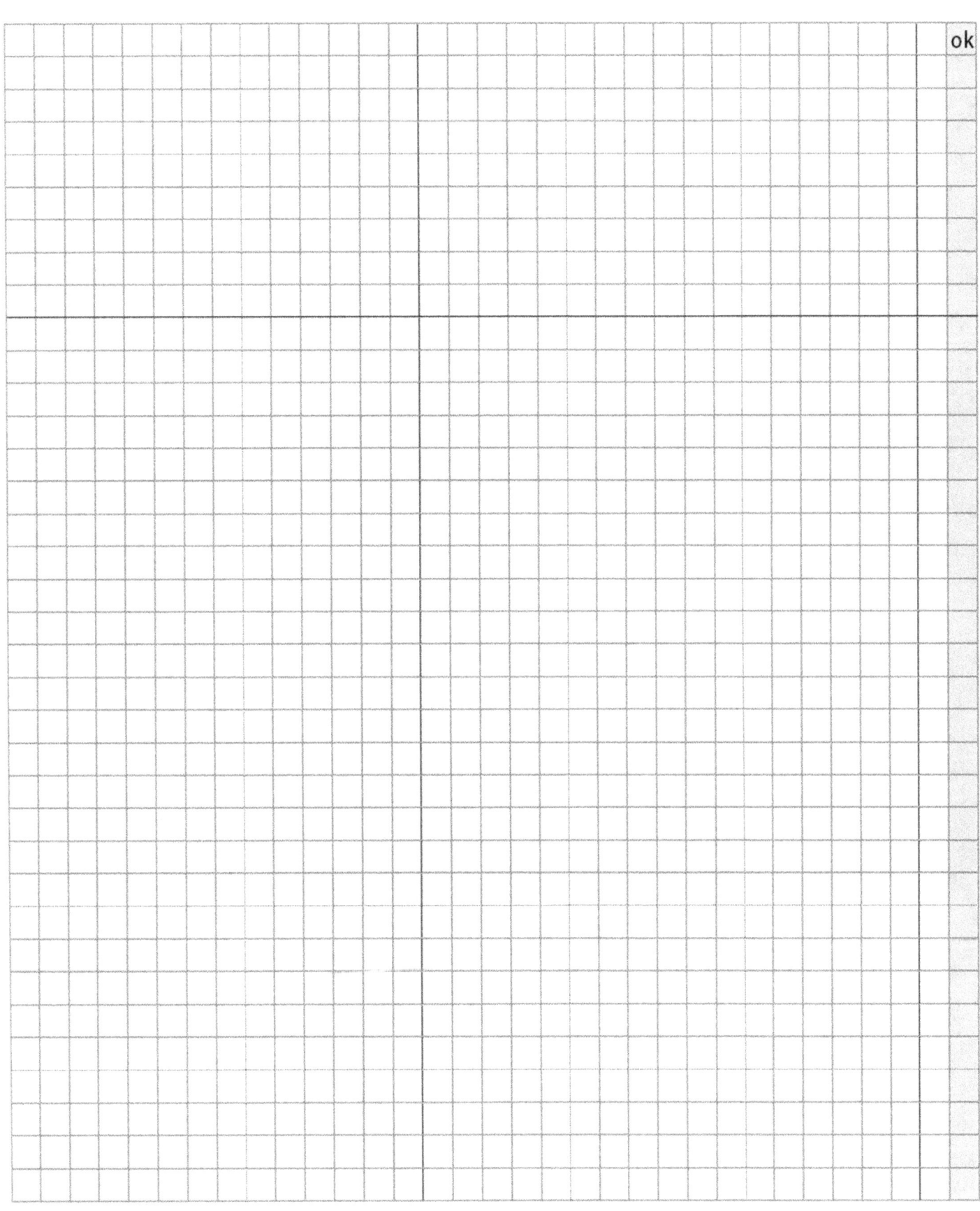

Topic

Person in charge

Date

Record/Report

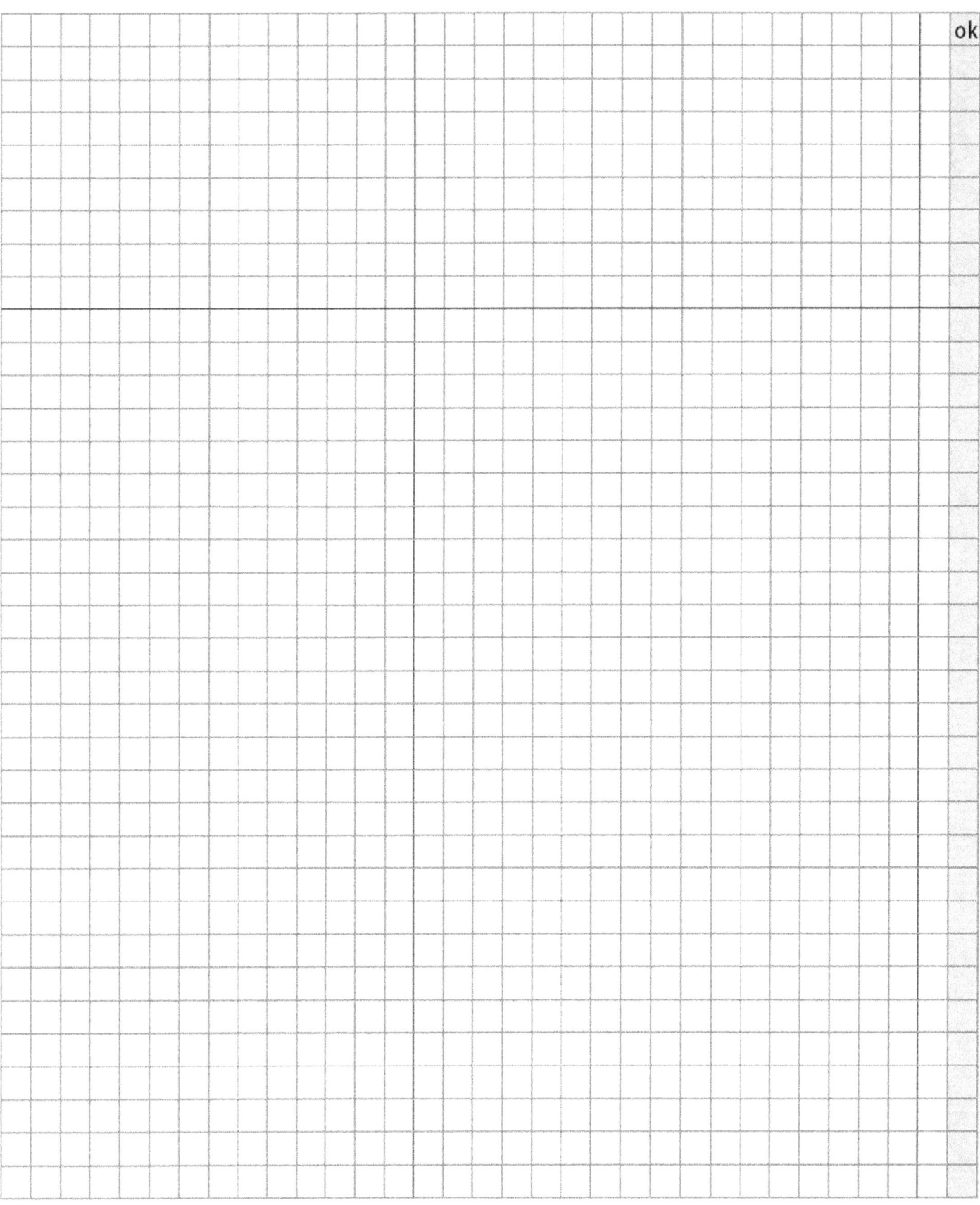

Topic _____

Person in charge _____

Date _____

Record/Report

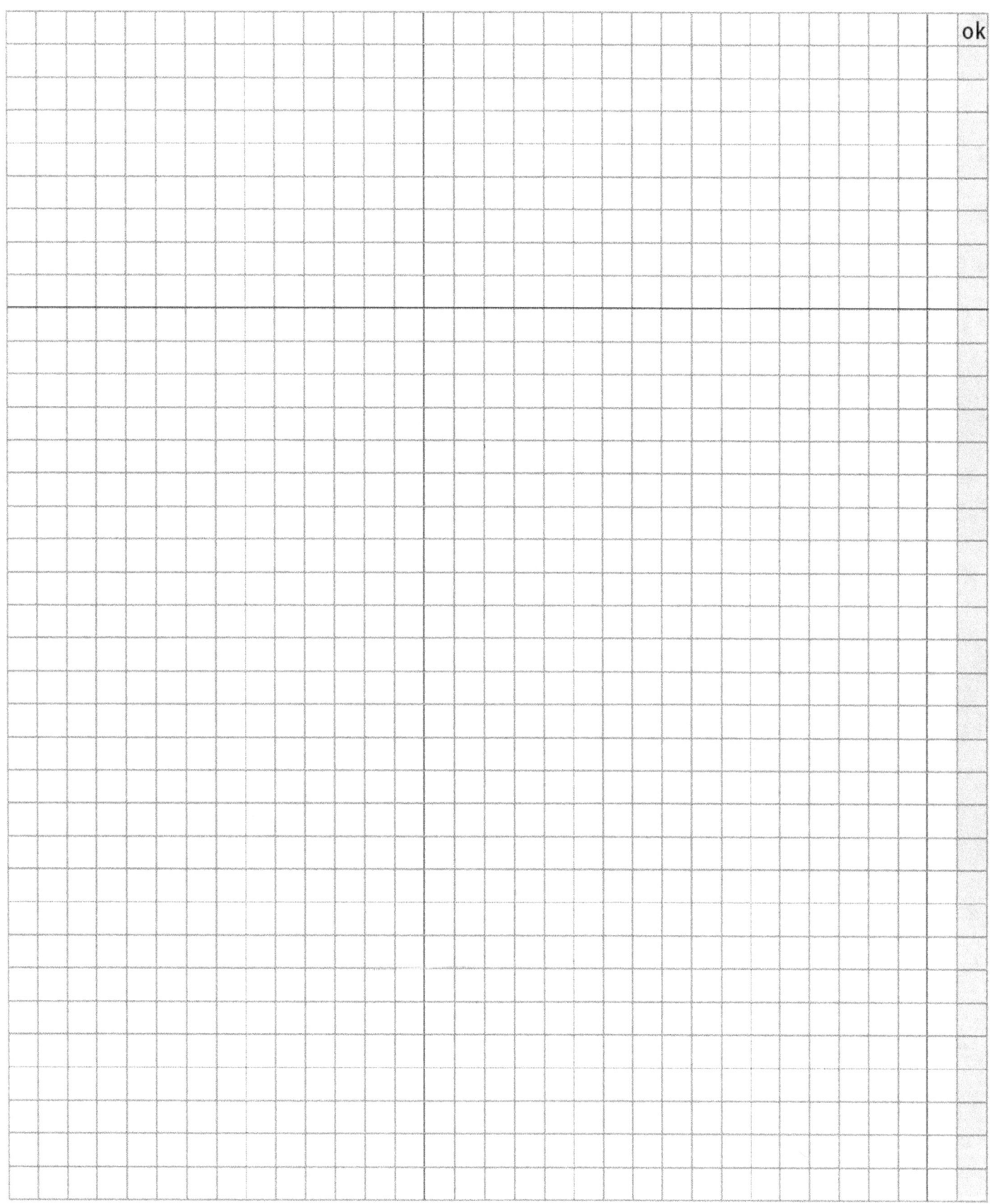

Topic

Person in charge

Date

Record/Report

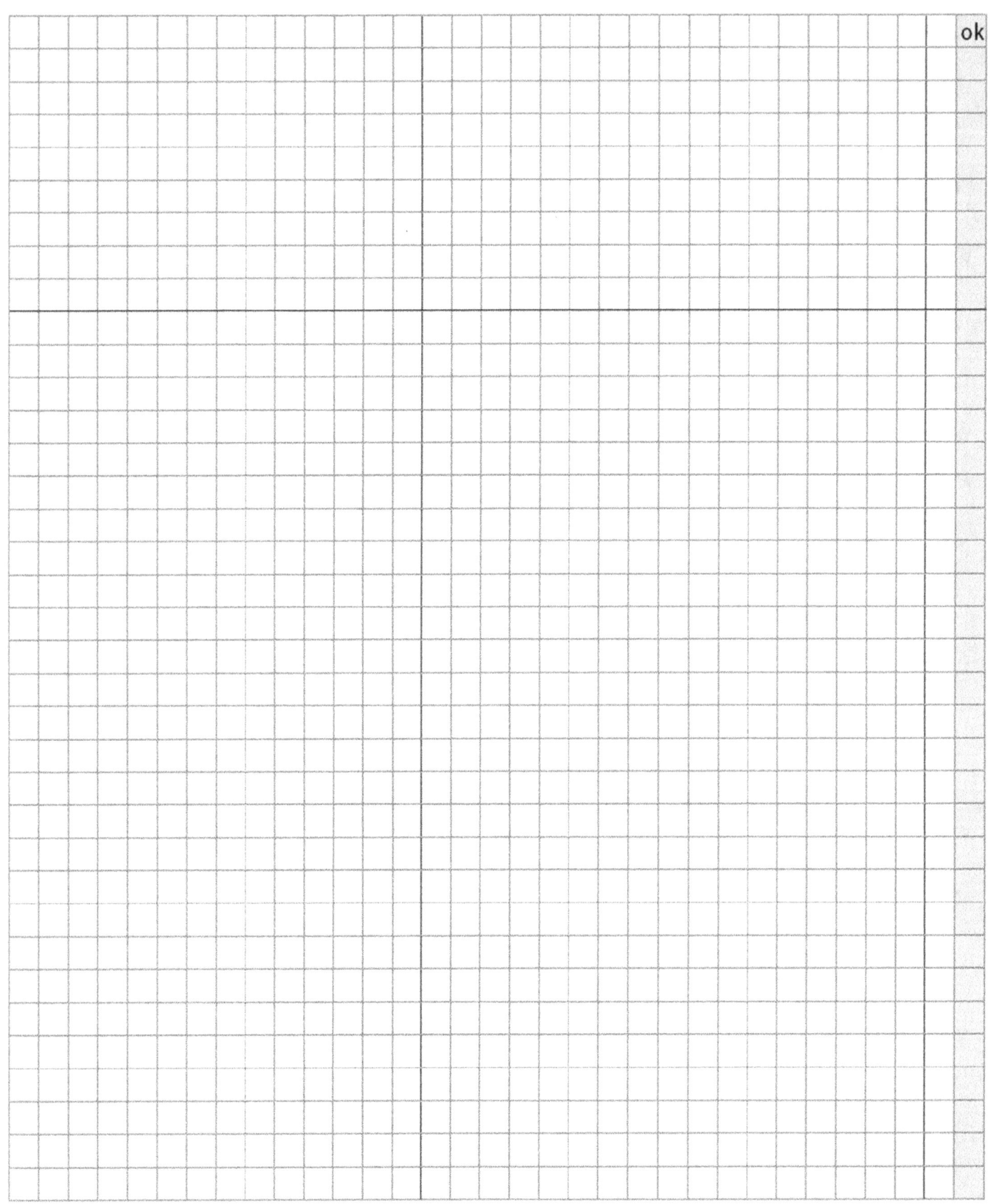

Topic

Person in charge

Date

Record/Report

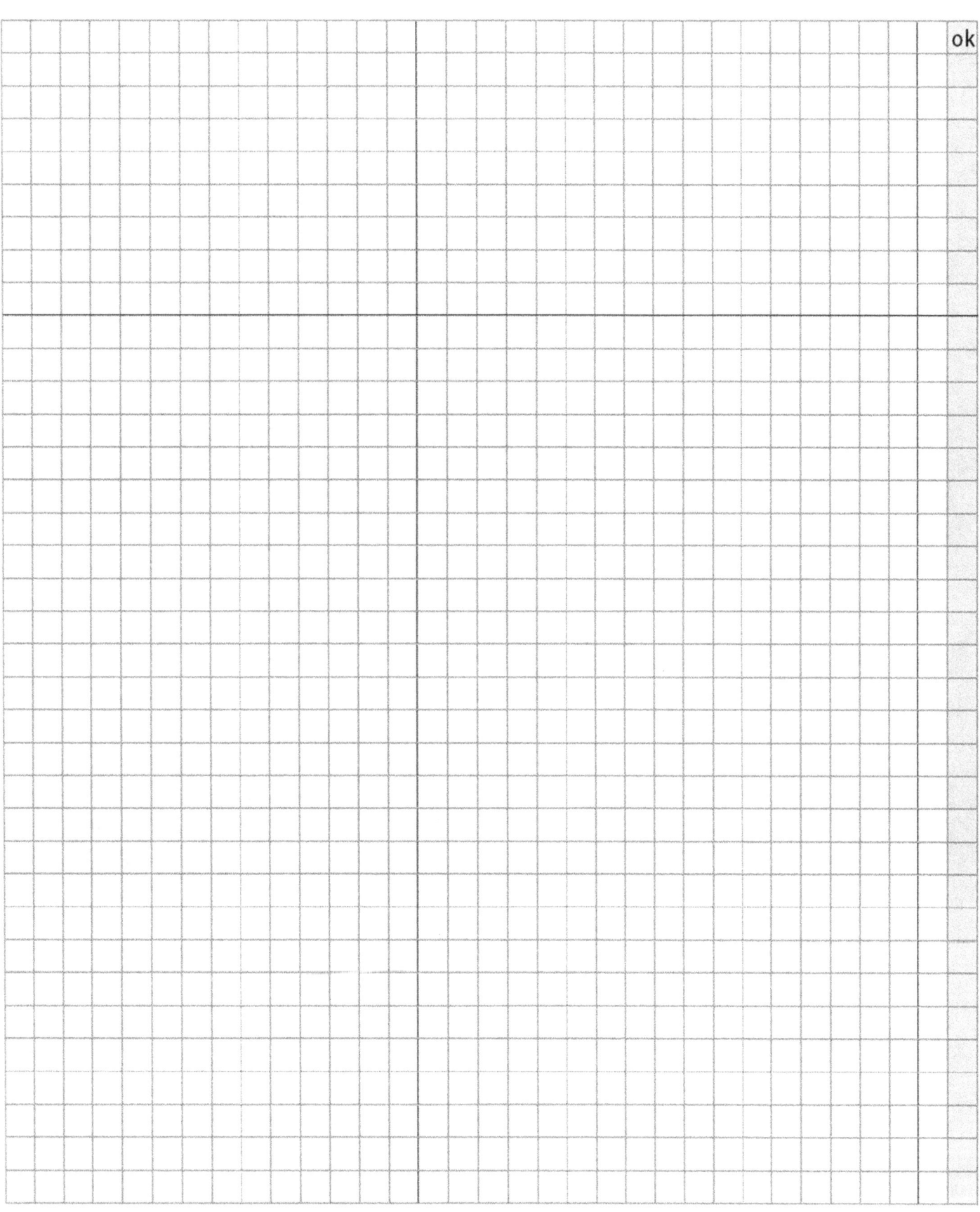

Topic

Person in charge

Date

Record/Report

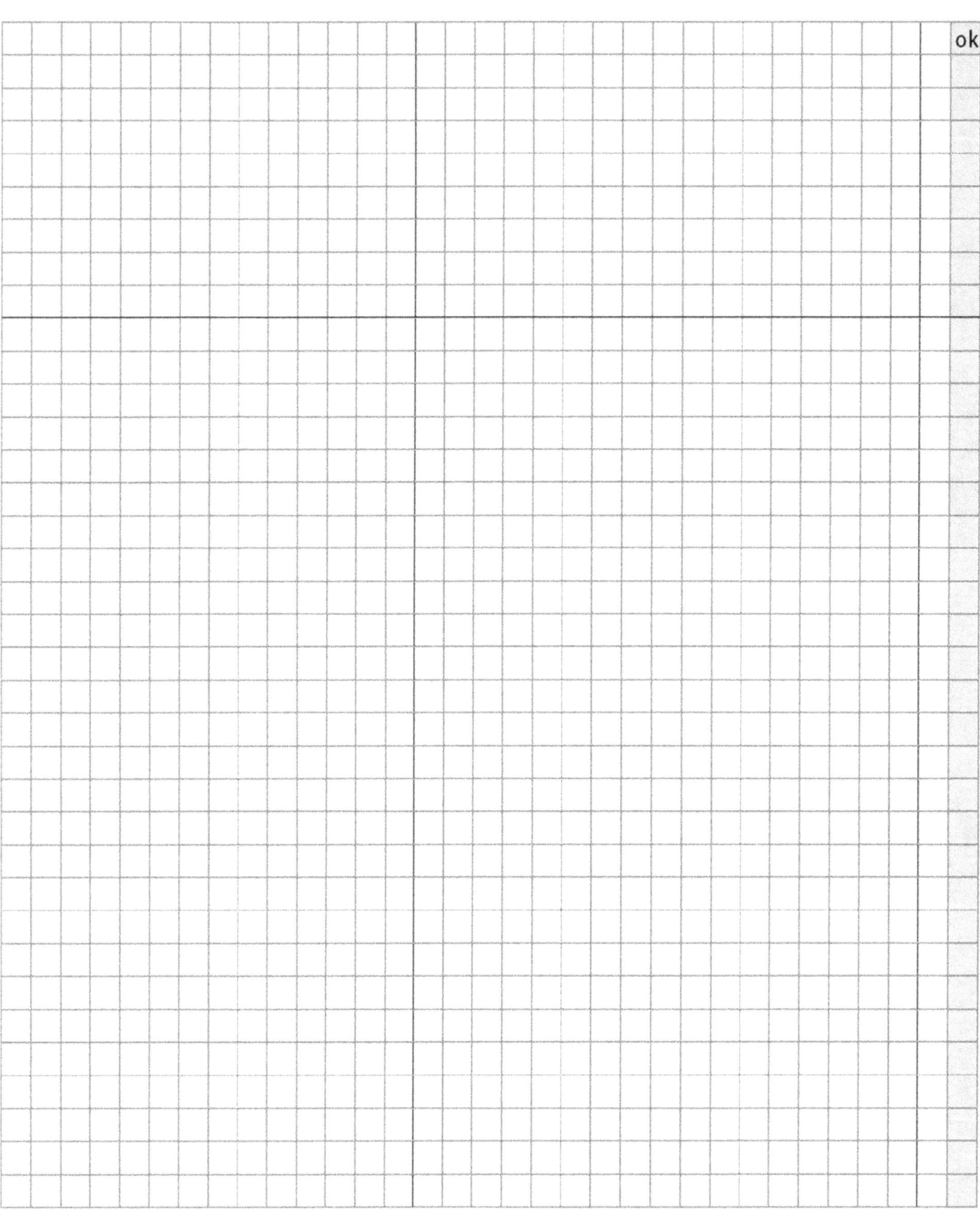

Topic

Person in charge

Date

Record/Report

Topic _____
Person in charge _____
Date _____

Record/Report

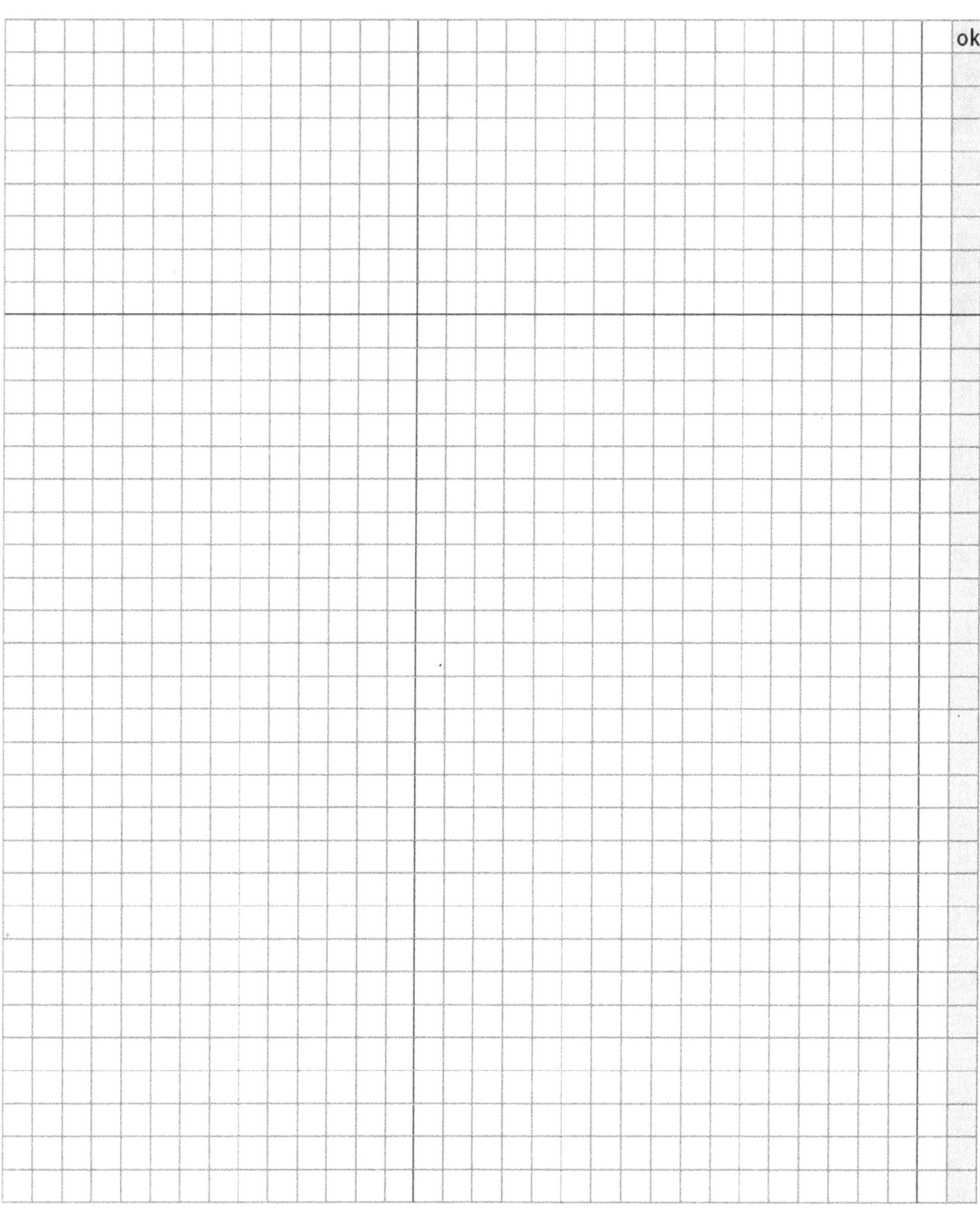

Topic

Person in charge

Date

Record/Report

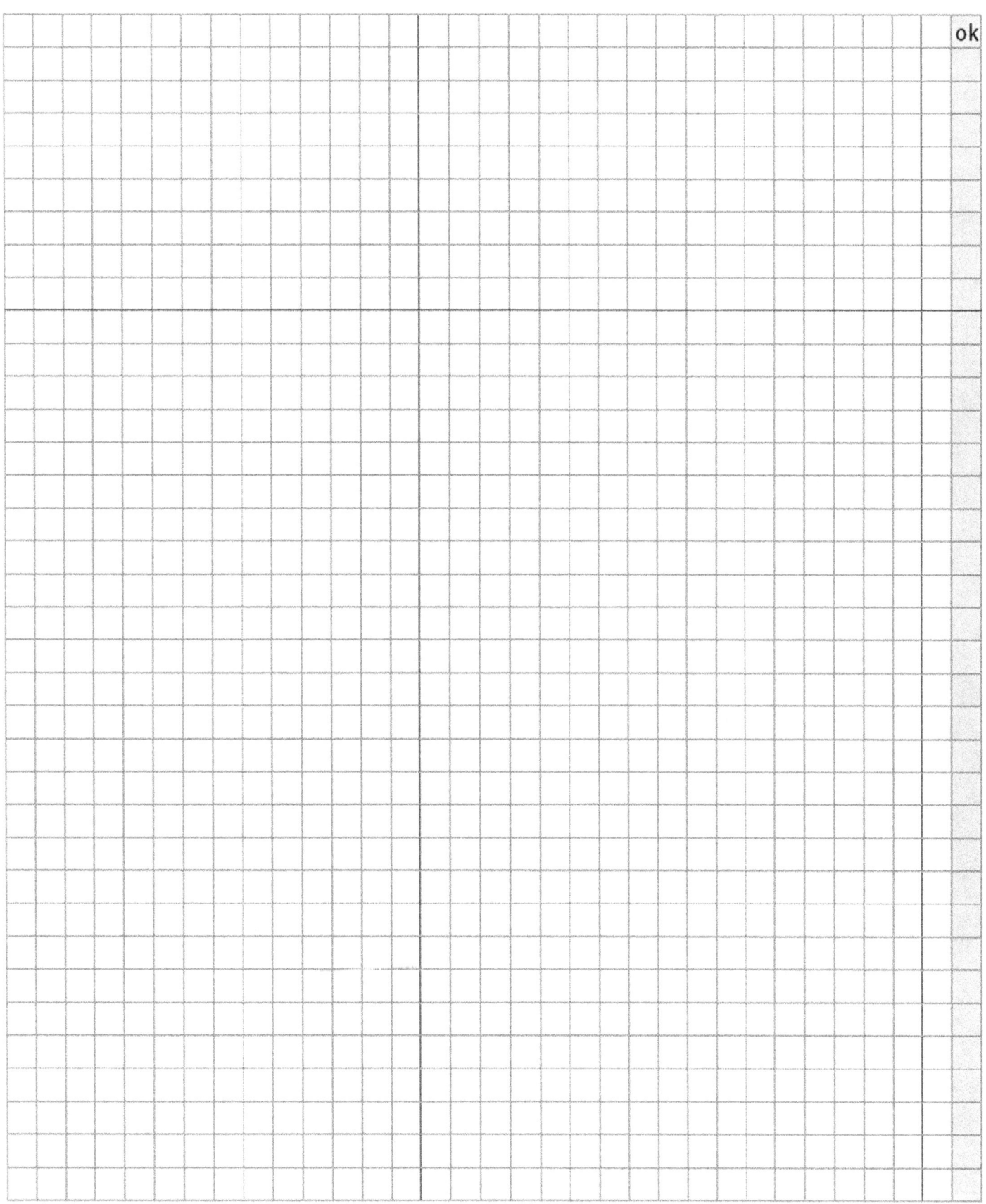

Topic

Person in charge

Date

Record/Report

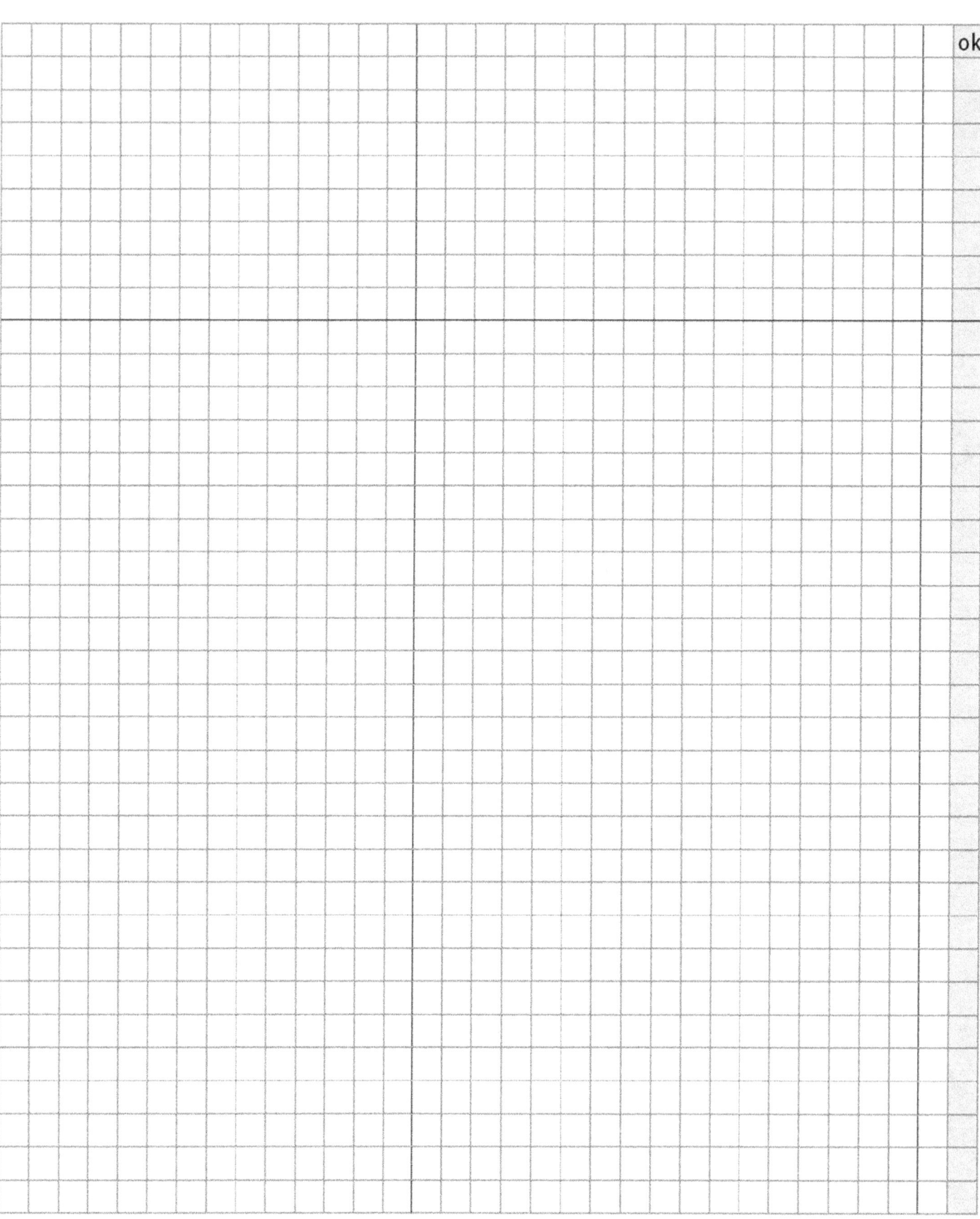

Topic
Person in charge
Date

Record/Report

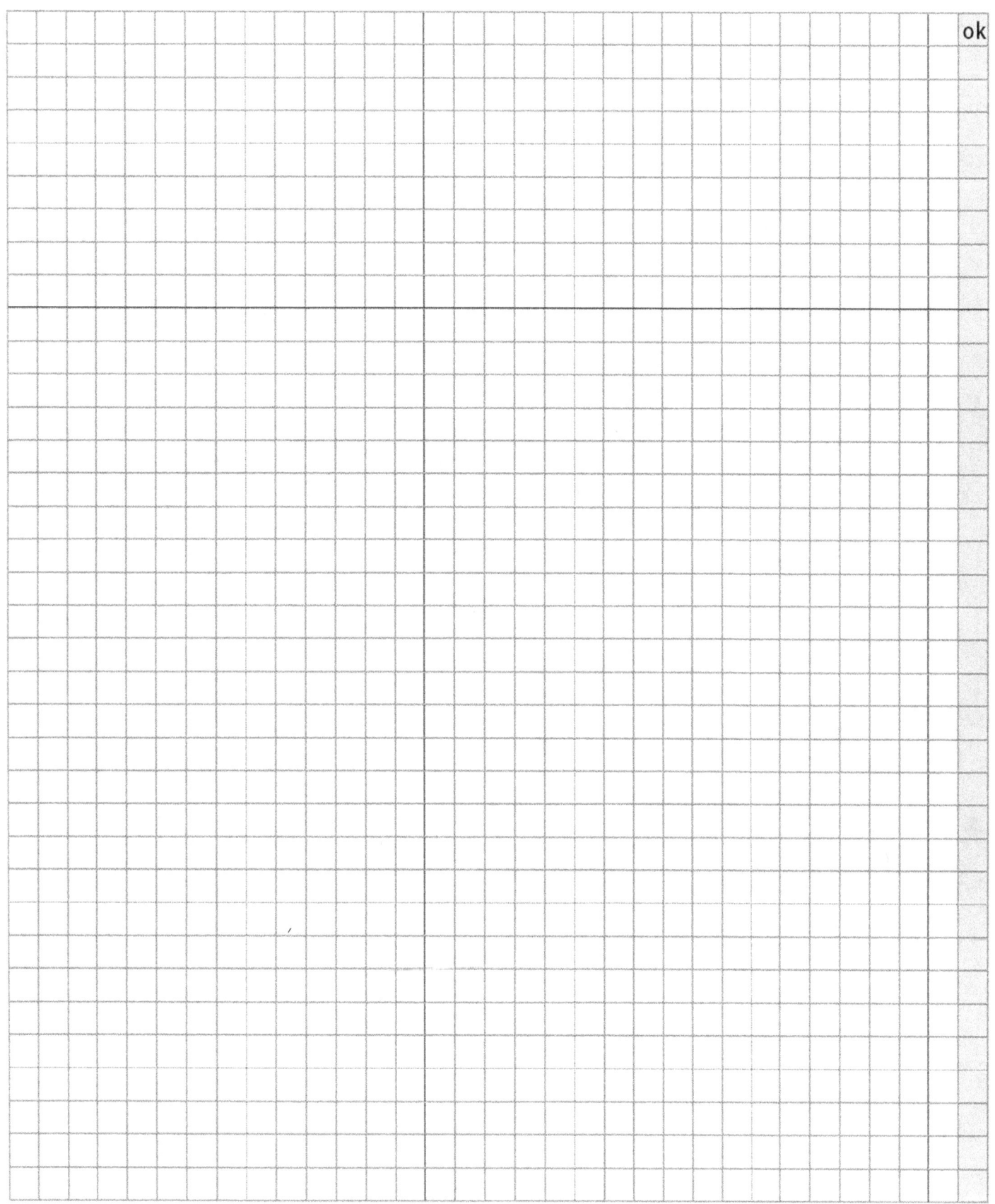

Topic

Person in charge

Date

Record/Report

Topic _____
Person in charge _____
Date _____

Record/Report

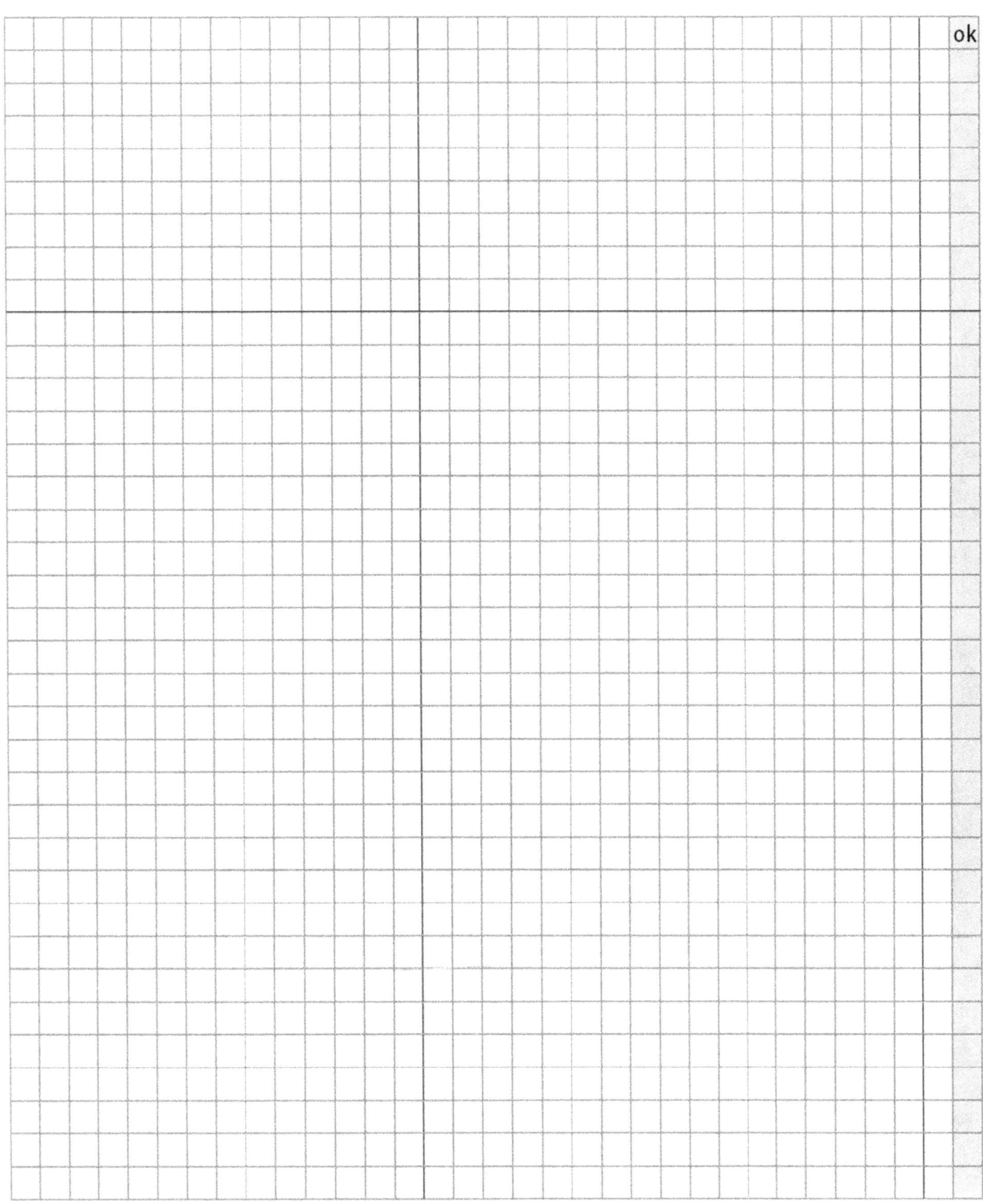

Topic
Person in charge
Date

Record/Report

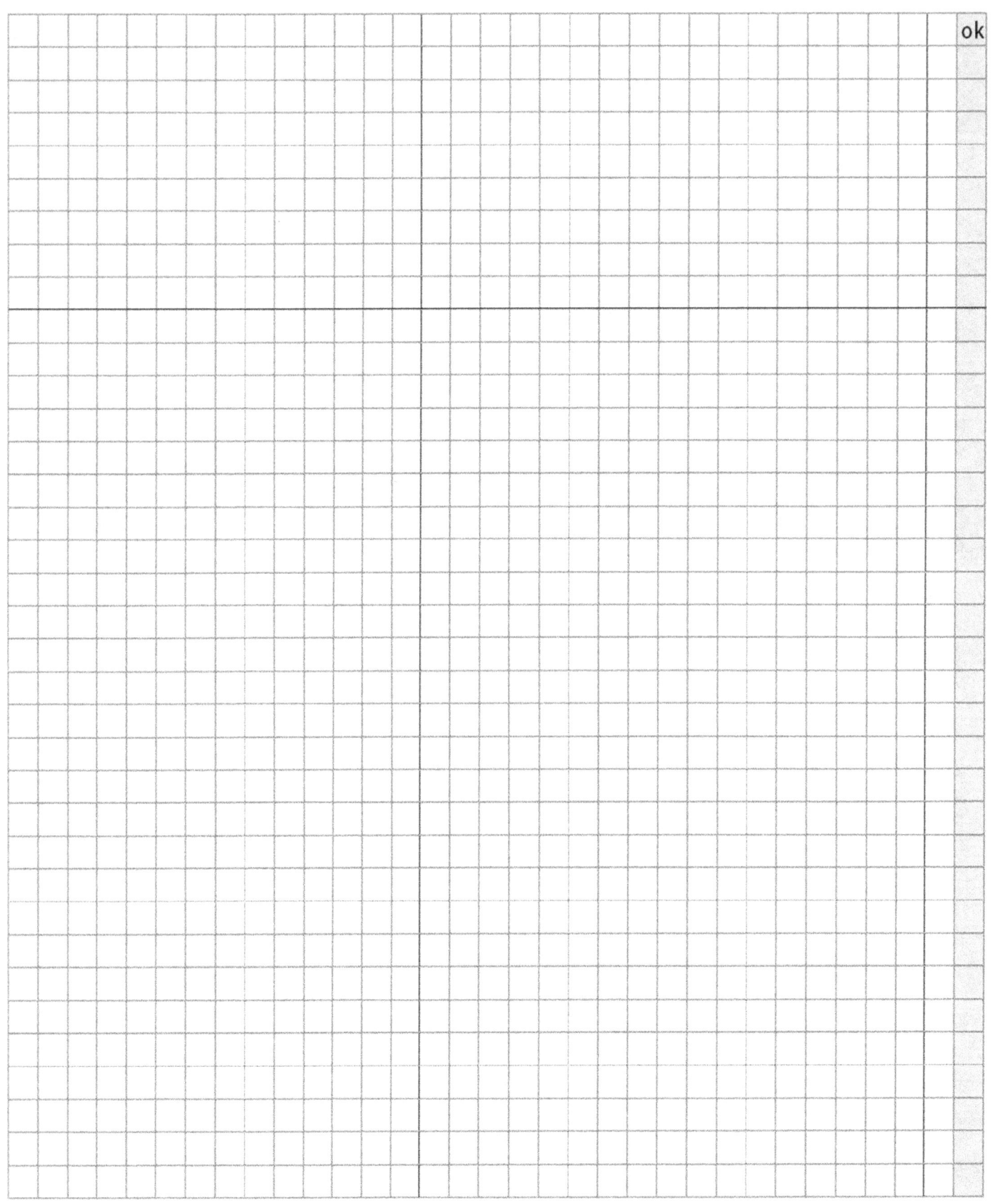

Topic _____

Person in charge _____

Date _____

Record/Report

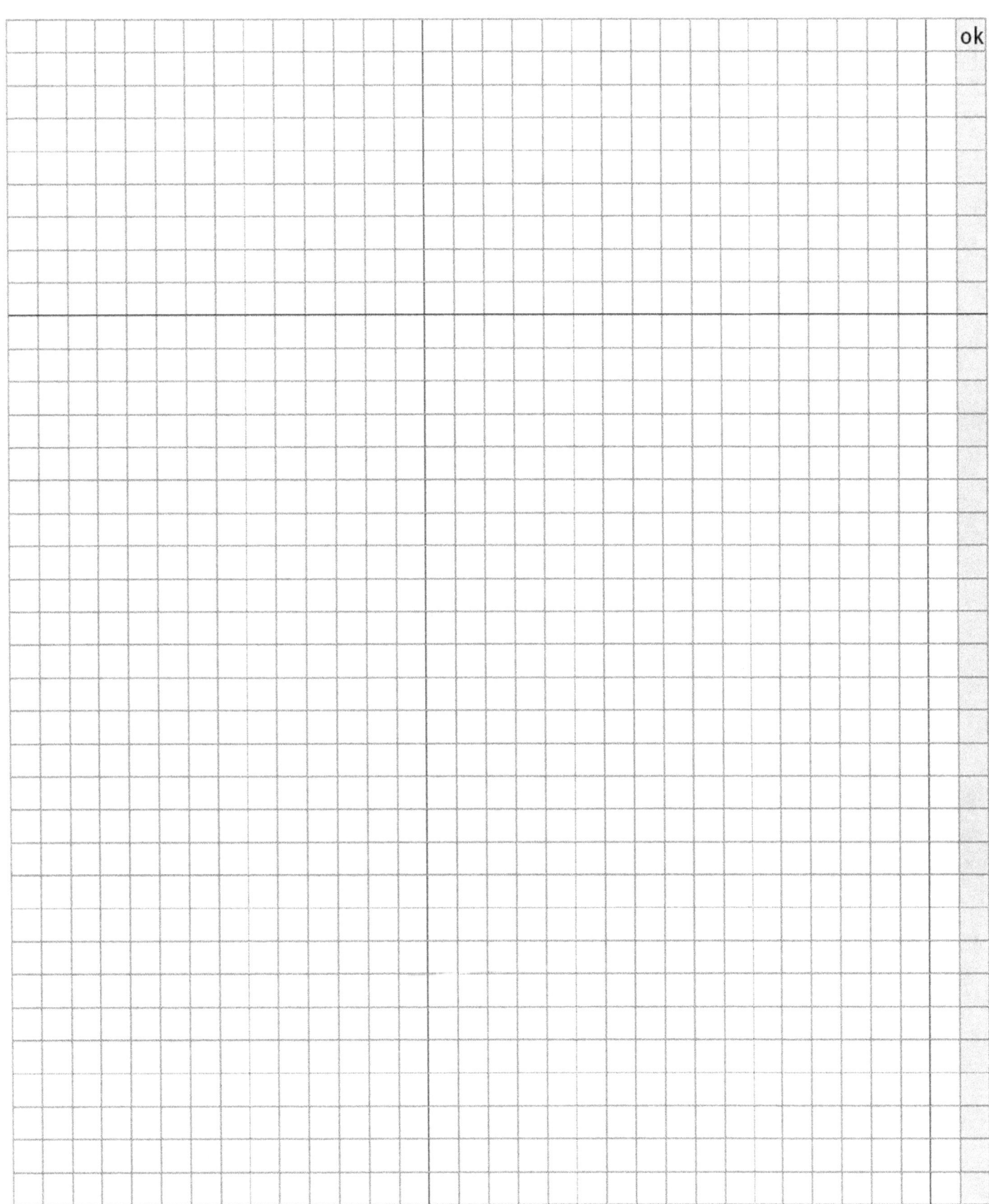

Topic

Person in charge

Date

Record/Report

ok

Topic

Person in charge

Date

Record/Report

ok

Topic

Person in charge

Date

Record/Report

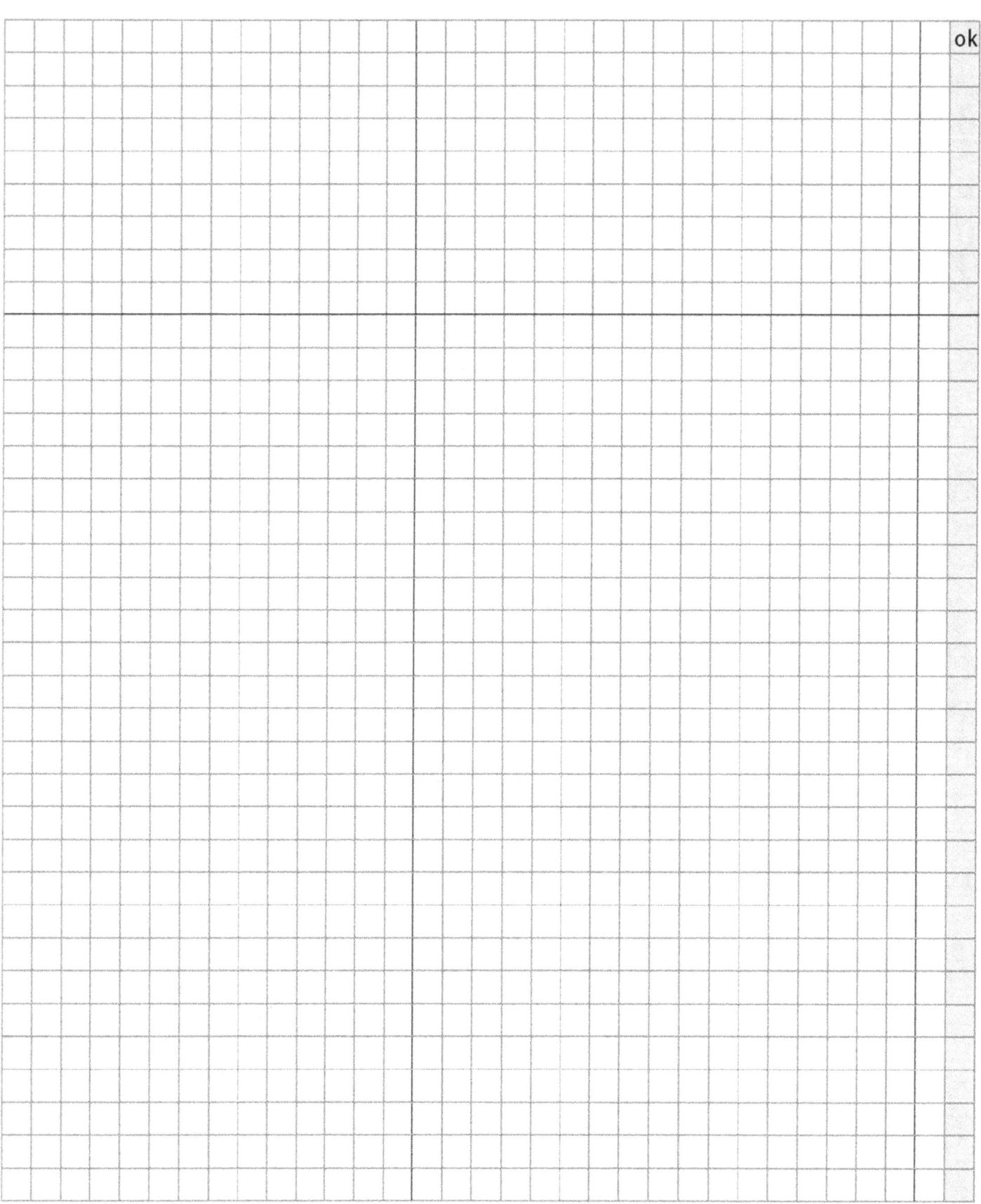

Topic
Person in charge
Date

Record/Report

Topic

Person in charge

Date

Record/Report

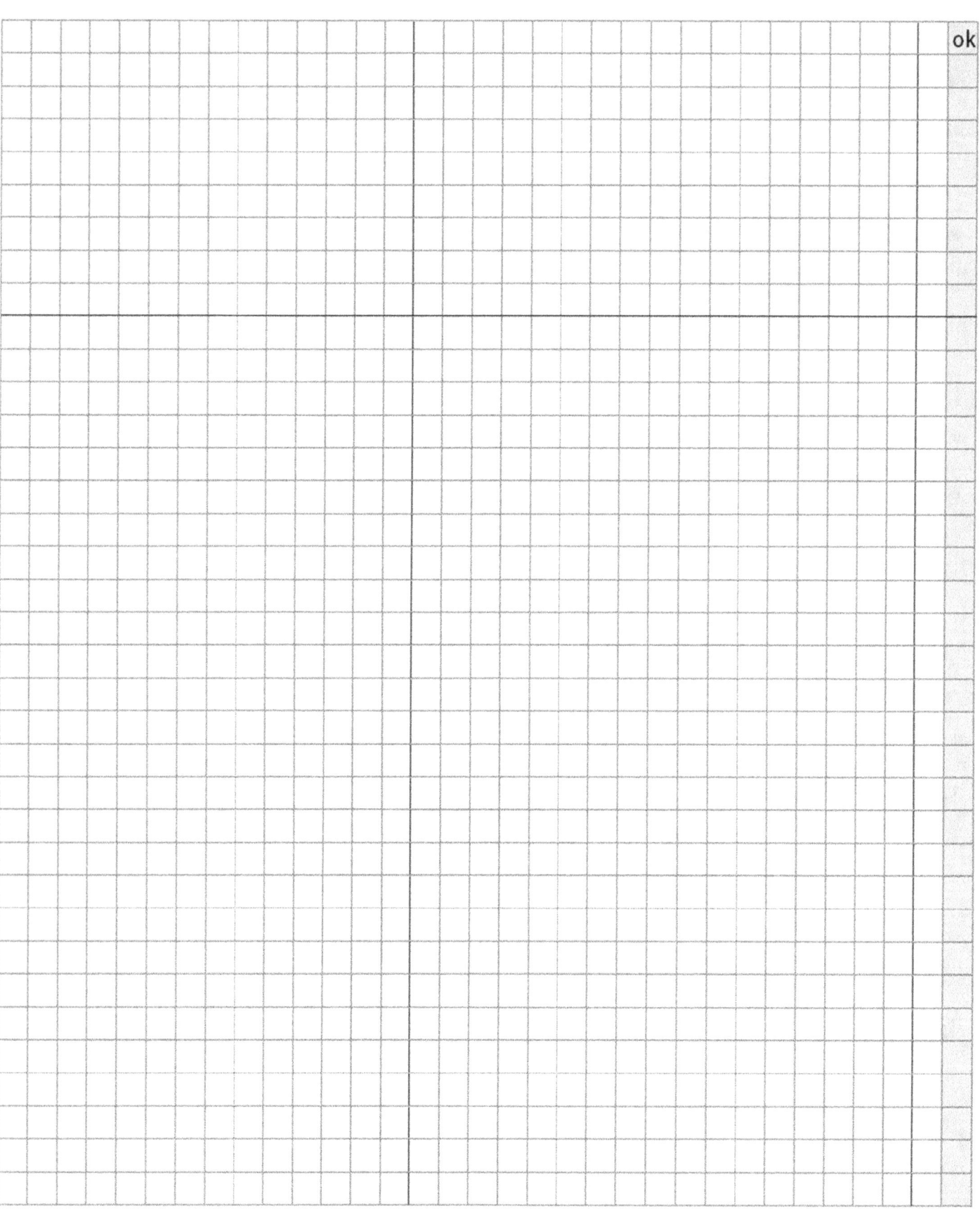

Topic
Person in charge
Date

Record/Report

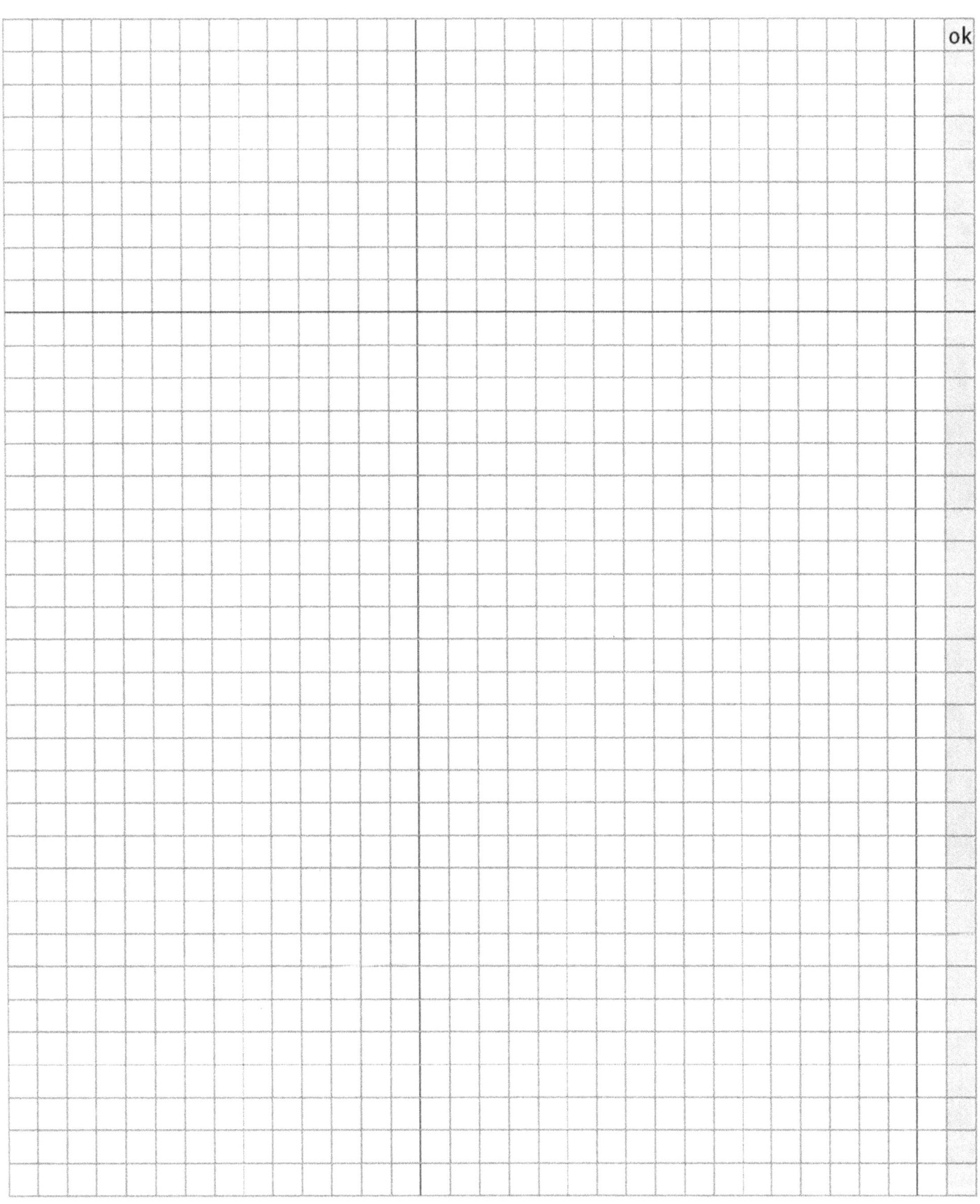

Topic

Person in charge

Date

Record/Report

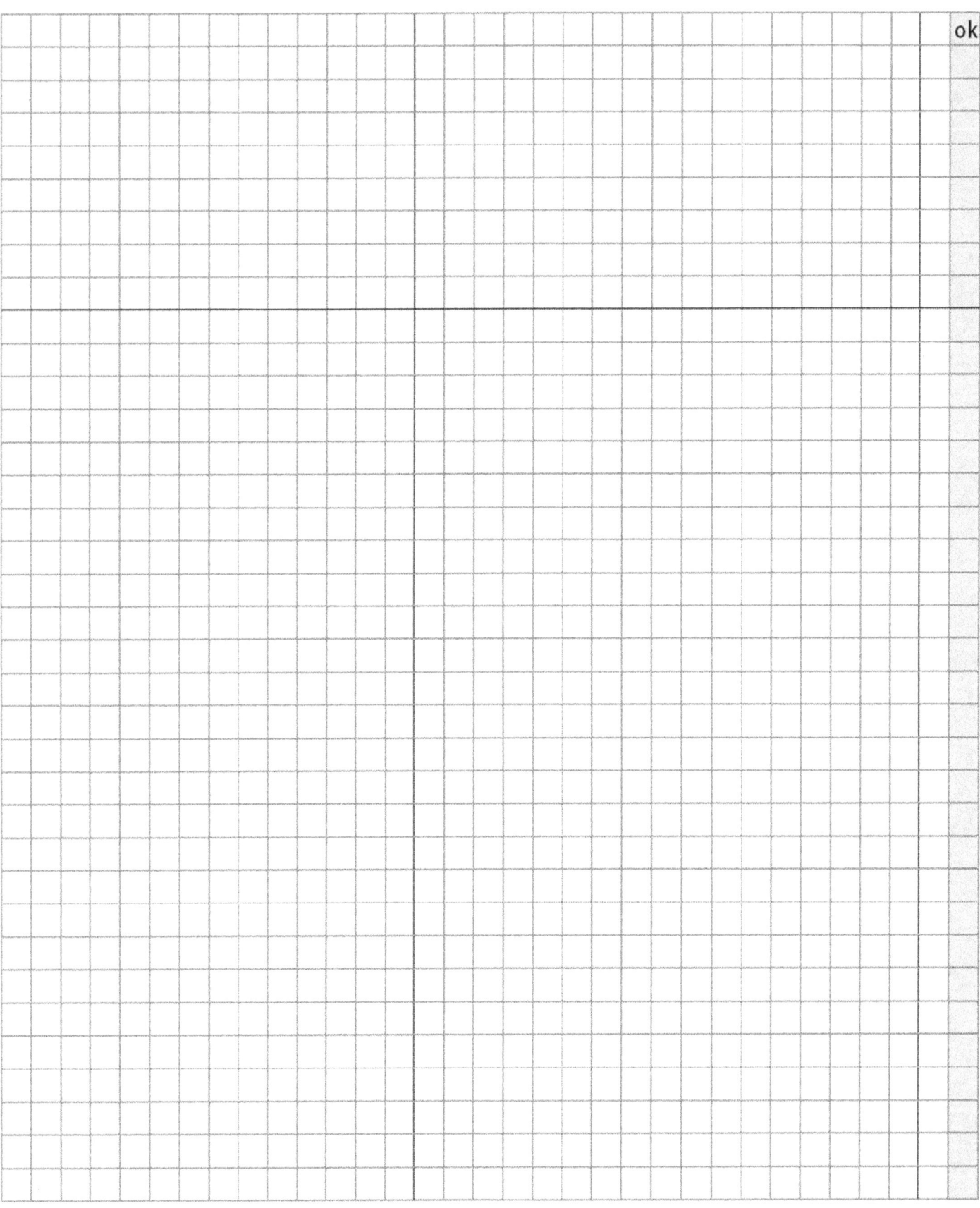

Topic
Person in charge
Date

Record/Report

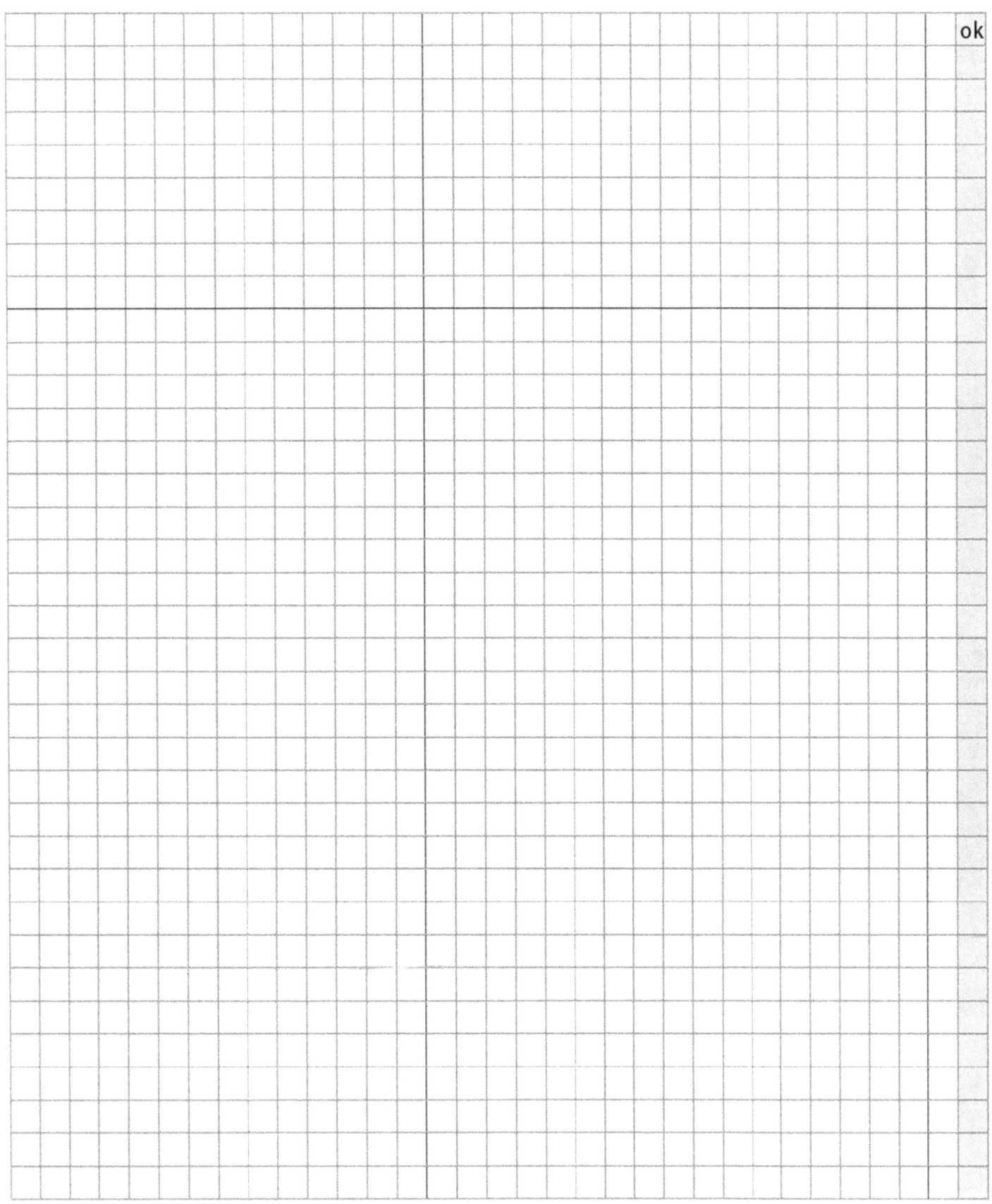

ok

Topic

Person in charge

Date

Record/Report

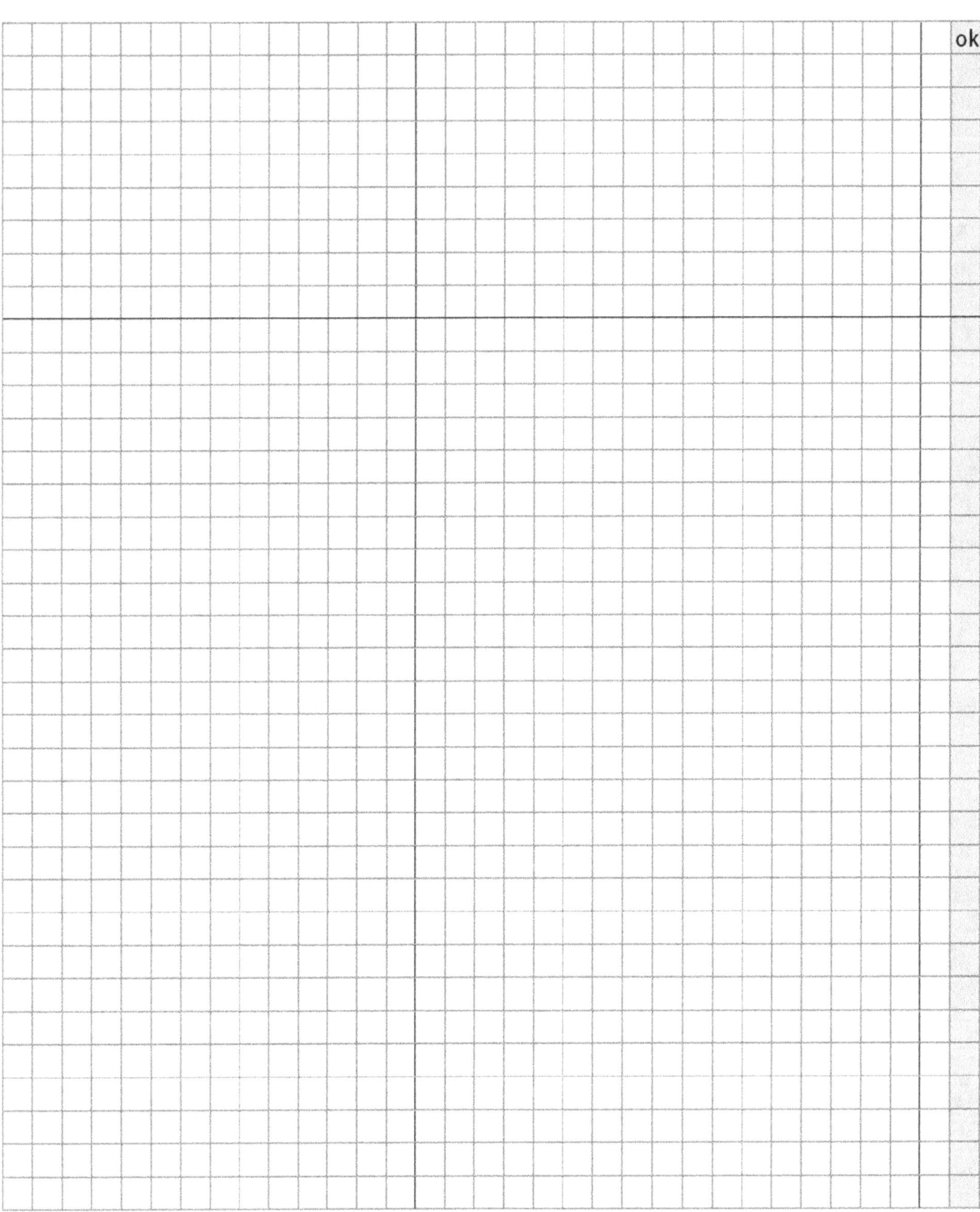

Topic

Person in charge

Date

Record/Report

ok

Topic
Person in charge
Date

Record/Report

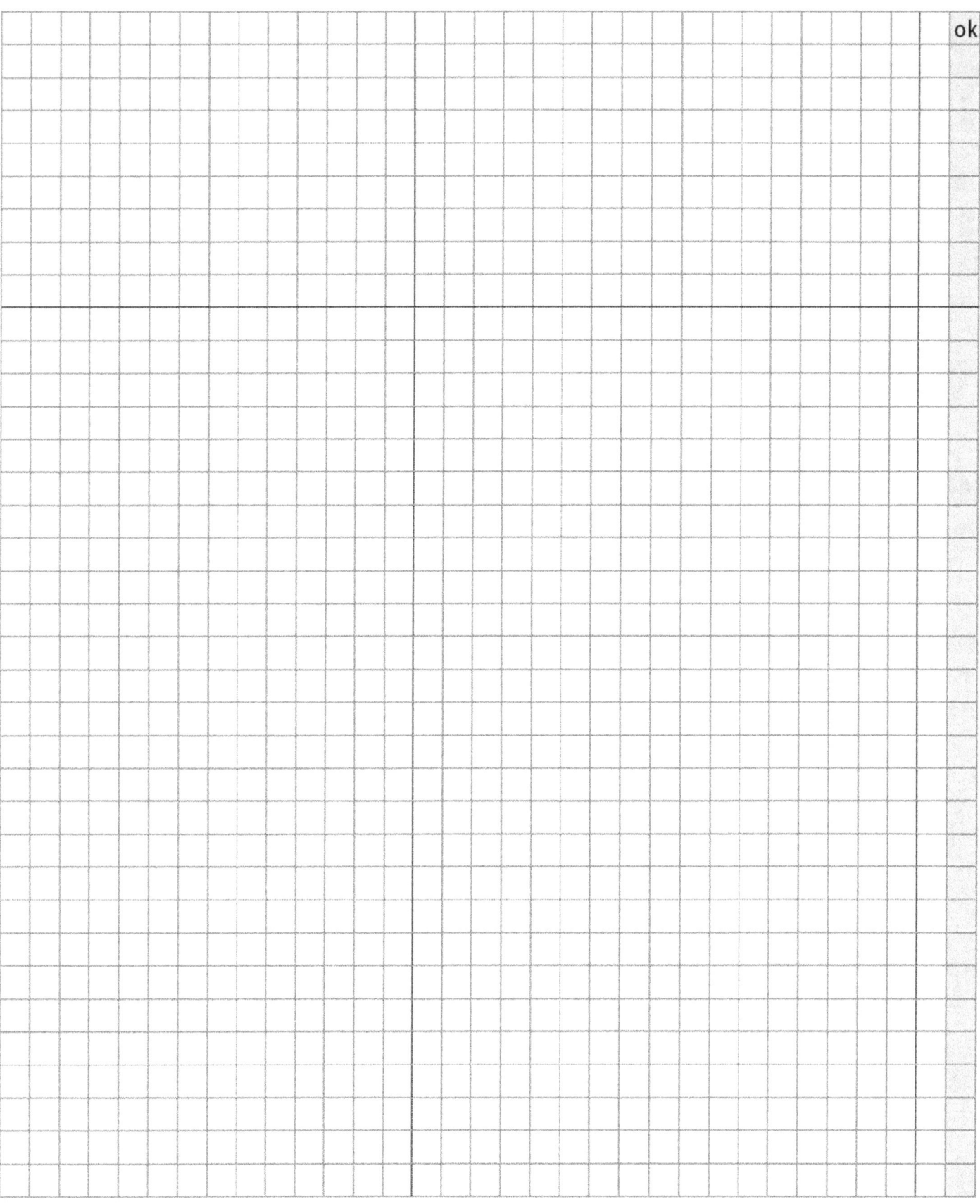

Topic
Person in charge
Date

Record/Report

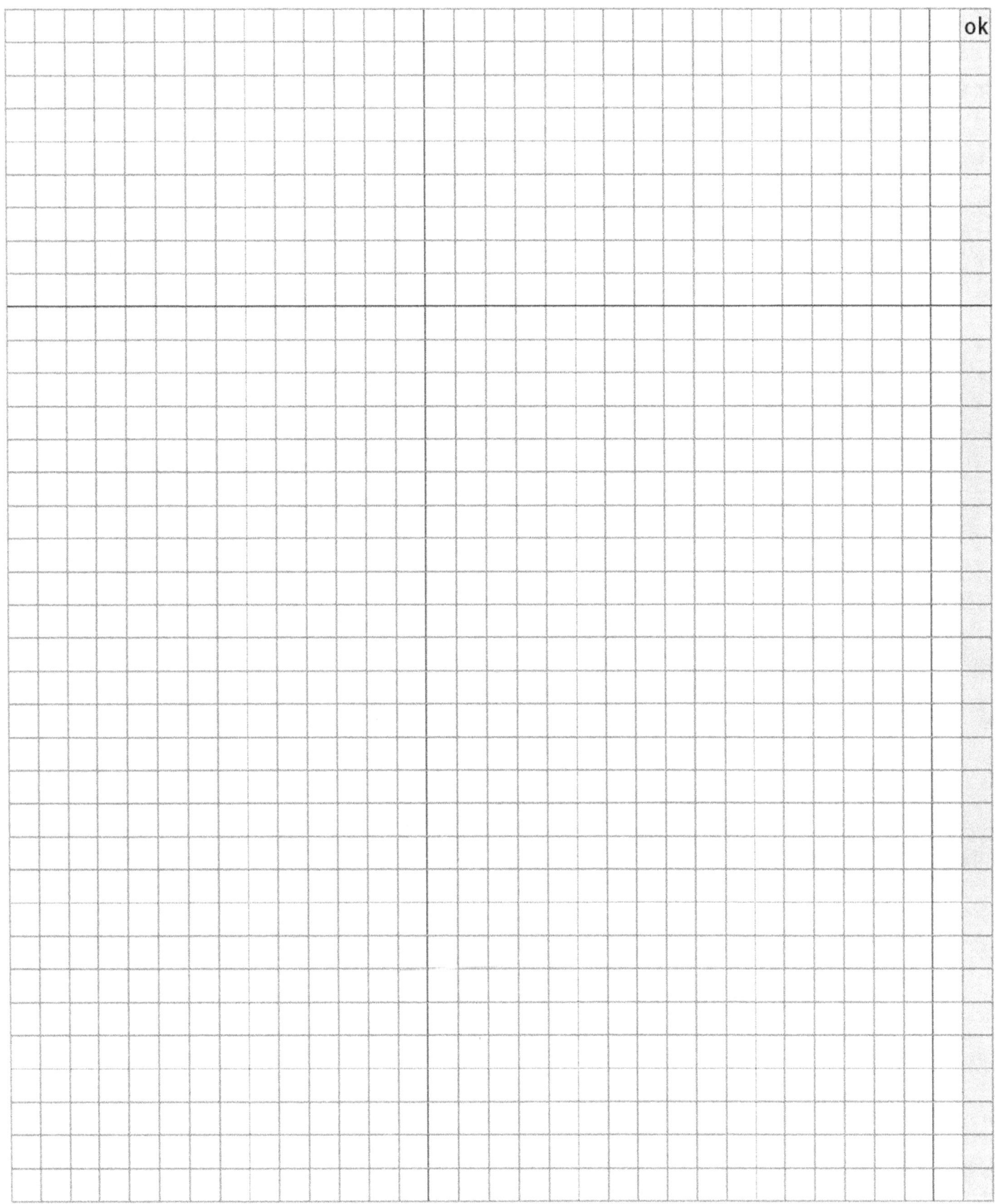

Topic _____
Person in charge _____
Date _____

Record/Report

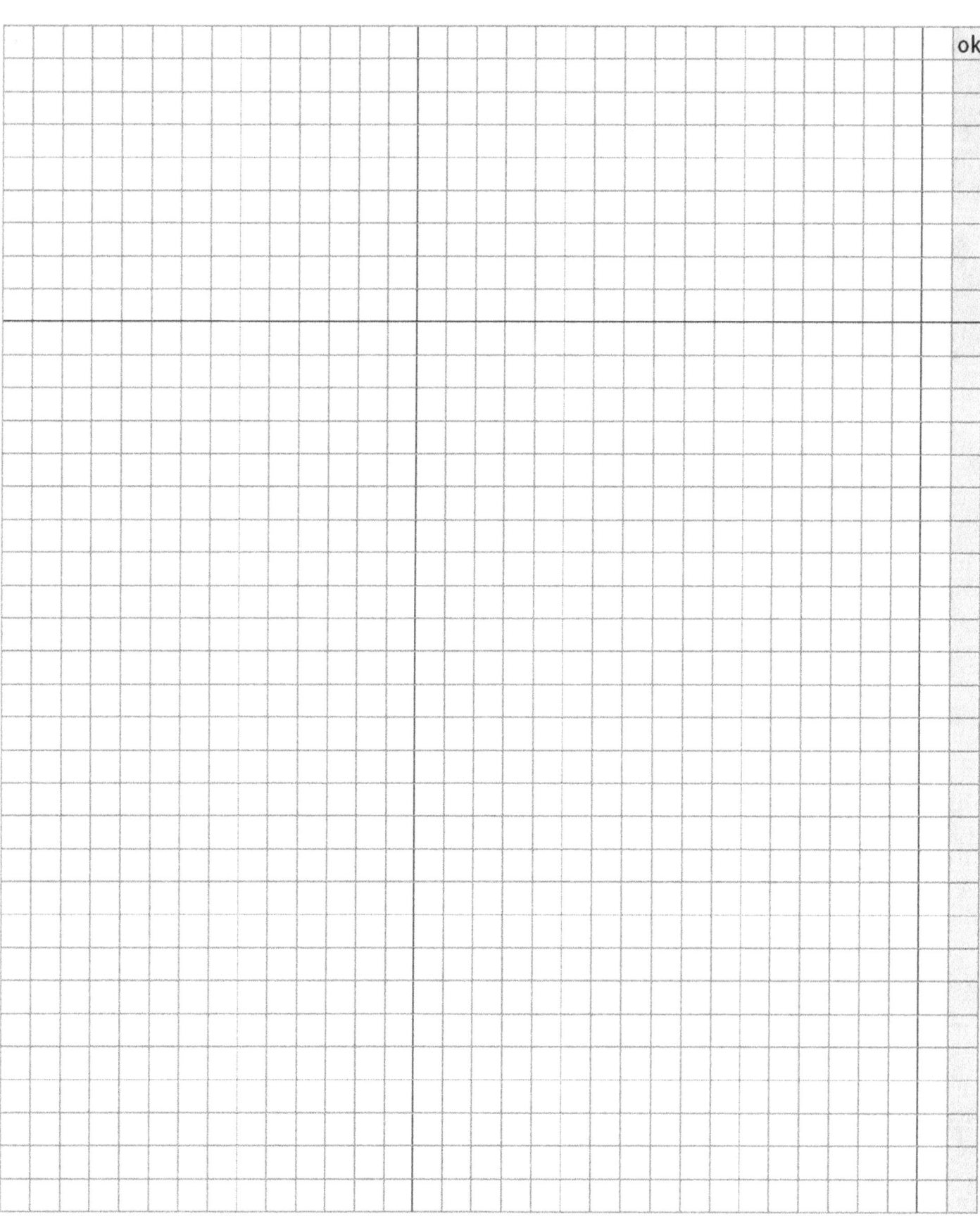

Topic

Person in charge

Date

Record/Report

Check List

Conclusion:

www.ingramcontent.com/pod-product-compliance
Lightning Source LLC
Chambersburg PA
CBHW080959170526
45158CB00010B/2845